THROUGH KNOWLEDGE I FOUND MY PEACE

AFTER SEPTEMBER 11, 2001:

MEMOIRS OF AN ARMY WIFE

Sakinah-Alaflah Cardona

Through Knowledge I Found My Peace after September 11, 2001:

Memoirs of an Army Wife

Written by Sakinah-Alaflah Cardona. Arthur S., (2012) Rivera, I., (2014) Correa, J., (2015) Published by Lulu.com.

Copyright © 2012 Sakinah-Alaflah Cardona. All rights reserved.

ISBN: 978-1-304-13409-7

*A*llah is the Arabic word, while

*T*he Lord is the English...

(3:84) Say (O Muhammad(peace be with him): We believe in Allah and in what has been sent down to us, and what was sent down to Ibrahim (Abraham), Ismail (Ishmael) Ishaq (Isaac), Ya'qub (Jacob) and what was given to Musa, (Moses), 'Isa (Jesus) and the prophets from their Lord. We make no distinction between one another among them and to Him (Allah) We have submitted in Islam).

This is the story of a soldier's wife who after September 11, 2001 decided to study the religion of the people that changed the world...Islam. Astonished when the news revealed who were behind the terrorist attacks of my favorite city, New York, I could not understand how people from the religion of my friends, the peaceful Muslims, were involved in such acts of terrorism. Mixed feelings invaded my thoughts, tipping the balance of peacefulness to disenchantment. What I never thought was that in trying to find truth I found a better answer of what I yearned for throughout my entire life. Peace that changed me inside out.

I have decided to share this story with you of my conversion to Islam and how all the questions that ran through my mind about religion were answered after September 11, 2001.

✦CONTENTS✦

ACKNOWLEDGEMENTS ... **21**

INTRODUCTION .. **25**

EPIGRAPH ... **31**

PREFACE ... **37**

<u>**I - WHAT TRIGGERED ME**</u> ... **43**

<u>**CHAPTER 1**</u> ... **45**

LIKE ANY OTHER PERSON ..45

2003-IDENTIFYING THE UNKNOWN ..46

SHARING WITH OTHER RELIGIONS ...48

<u>**CHAPTER 2**</u> ... **51**

OUR DESIGNATED RELIGIONS ...51

THE DAY THAT CHANGED THE WORLD ..57

THE YOUNG SOLDIER ...60

<u>**CHAPTER 3**</u> ... **63**

THE OTHER WITNESS OF WAR ...63

LEARNING + FAITH = SUBMISSION TO GOD65

II - BETWEEN TWO WORLDS "MEMORIES" .. 71

CHAPTER 4 .. 73

MY UPBRINGING ..73

MY MOTHER ..77

DIFFERENT CULTURES ...81

CHAPTER 5 .. 85

HIS CHARACTER SEEMED LIKE A ROCK ...85

IS WHAT WE SEE ALWAYS THE TRUTH? ..88

BE A CARPENTER, BUT BE SOMEBODY! ..92

CHAPTER 6 .. 97

A LESSON TO CLEANSE MY SOUL ...97

I ASKED AND BELIEVED ...100

FAMILY VALUES ..104

CHAPTER 7 .. 109

SEVEN YEARS OF MARRIAGE AS NON-MUSLIM109

ARE SPELLS REAL? ..114

III - VALUABLE RECOLLECTIONS ... 121

CHAPTER 8 .. 123

LOVE CONQUERS ALL .. 123

TRYING TO ADJUST TO THE MILITARY LIFE ... 126

IS SANTA CLAUS RICH OR POOR? ... 135

CHAPTER 9 .. **139**

LESSONS FROM GOD ... 139

MY TRAUMA ABOUT ADAM AND EVE .. 141

CHAPTER 10 .. **147**

DIFFERENT WAY OF LIFE ... 147

LOVE AT FIRST SIGHT ... 152

CHAPTER 11 .. **159**

THE LAST DROP THAT GAVE ME FREEDOM ... 159

IV - EDUCATION MADE ME DO IT .. **165**

CHAPTER 12 .. **167**

THE LAST PIECE OF THE PUZZLE ... 167

WE ALL ARE THE SAME, ONE COMMUNITY ... 173

CHAPTER 13 .. **177**

THE LORD WORKS IN MYSTERIOUS WAYS .. 177

RACISM OR IGNORANCE? ... 183

| THIS MAKES SENSE TO ME!..189 |

CHAPTER 14 .. **199**

| IT'S ALL ABOUT POWER AND CONTROL...199 |
| GOD WORKS IN MYSTERIOUS WAYS! ..209 |

CHAPTER 15 .. **215**

| I AM A MUSLIM NOW!...215 |
| DIFFERENT WAY TO LIVE ..220 |

CHAPTER 16 .. **231**

| I AM WEARING A HIJAB!..231 |
| BLESSINGS FROM MY CONVERSION TO ISLAM234 |

CHAPTER 17 .. **239**

| THOUGHTS IN 2013 ..239 |

CHAPTER 18 .. **247**

| THE LAST SERMON ..247 |

ACKNOWLEDGEMENTS

All praise and thanks be to Allah, we praise and thank him. We seek his aid, and we seek his forgiveness.

We seek Allah's refuge from the evils of ourselves and from the evils of our actions.

Whosoever Allah guides, no one can misguide; and whosoever Allah misguides, no one can guide.

I testify that none has the right to be worshipped except Allah alone; having no partner, and I attest that Muhammad is his slave and his messenger.

INTRODUCTION

Originally I began to write this book in 2003 during a time at which not a lot of people knew much about Islam. The intention was to write a speech in which I inform the people about how I found my peace changing the way I was directed to think all my life. As a girl I had many questions and the answers of having "faith" was not convincing my intellect who instead was fed with more doubts and confusion. I wanted deeper answers the ones in which I can say; yes, this makes sense to me!

As we all know September 11 tragedy left a deep wound in the heart of everyone in the world. The thought, that Muslims were terrorists was a theme difficult to approach. While I was invited to deliver my speech in a few places I began to see how many people was in the same situation that I was before I changed my life: they needed an answer that can help them to understand the mysteries of this world. A religion or "way of life" that makes sense to them.

The second intention was to allow friends and family know what was the reason of my big change while reading about the experiences and questions that I had all my life in which many of them where witness. I began to write a simple book, with simple stories, which would be referenced as "my love story" or "my family memories" Eventually I became excited and involved with "the stories" that I ended writing more pages than intended.

The year is now 2013 and many things have occurred since that frightful autumn day in New York. Many countries are living in a recession, leaving some without jobs and governments scrambling to find solutions to problems. Revolts like those of the Arab Spring and

the numerous shooting massacres happening around the United States are prime examples of the changes that are occurring worldwide.

As if nature was trying to get in tune with the chaos, in the environment; tsunamis, hurricanes, tornadoes, earthquakes, all presented themselves with hideous aftermaths and destruction. In some places the crime rate has risen to the point of forcing its residents into prisoners of their own home for fear of home invasions or simply being a victim to circumstance. The world lives in chaos and soon fear and paranoia will be the evening headliners.

All of the above has happened after September 11, 2001, as if a big lesson was trying to be taught. Contrary of what anyone expected many people keep converting to Islam Perhaps the encoded curiosity and desire of humanity will lead to a search of spirituality or consideration for the amazing result of creation? Perhaps The humanity will reflects to consider such creations like the infinite ocean or the sky must be created by someone more powerful and vast than a mere human being? Perhaps, that someone, wants individuals to change their way of life?

Before I tried to put these pages together I had many doubts about concepts. Like a new Muslim that I was I misunderstood many things, it was not until someone introduced me to the right person who has the Knowledge and ability to teach. She teaches the truth about Islam with evidence of Quran and The Sunnah, which are the examples of the life of the Prophet.

Perhaps I made a big mistake; I did not ask anyone for advice, the intention was to write exactly what I had on my mind while I was searching for peace. That is what you are going to read. I am giving to you some experiences during the time that I was looking for a religion and a different way of life, one that make sense to me. Some of the pages that I wrote were before I took my classes therefore

after reevaluation new pages with different experiences replaced the old ones.

What makes me excited every time I went to my class was to discover that whatever concept I learned in my search to find Peace, was right. Such information about why God sent the prophets, scientific discovering's from today that were already written in The Quran, The Woman in Islam and Laws about our different way of life, which is what attracted me more. However as a new Muslim, I had the arrogance to think that I knew everything! I was wrong, with my teacher I learned deeper of what anyone can learn; with her I learned things that make me love more this religion, the most important things, which is how to Love Allah, Who is Allah? Where He is? Things about the life of the devil and his army, how to protect from the devil, what is the goal of every Muslim, how the heaven and the hell looks like, the signs of the last hour, how to keep our faith strong, how to have a good heart, the real nature of a human being and many other things that this great teacher is teaching every day and the things that I still learning.

This book is a simple book. A book filled with simple stories of my life in which I recall how some experiences triggered my inner desire to search for peace amongst the surrounding chaos. Such are the stories of my youth, my marriage, military life, and my conversion to Islam as an Army wife in the midst of a nation at war. The same way many people are today searching for that "need" or that sense of tranquility. Our intellects can perceive that something is happening they know is for a reason and that something might be a key indicator that as human beings we may have to reevaluate the way we live and or think.

We aim to be a salad bowl full of different flavors and colors, each with its unique purpose, yet we act as a melting pot aiming to out-do the other with materialism, work, sports, or fame, the list could go long. For the individuals with a different mentality not

conforming to their set stereotype see far from of what we have been taught. They are the kind that do not give up and try to find the original piece of the puzzle to obtain the best and ultimate reward...peace.

Surah 5. Al- Maidah 32

Because of that, we ordained for the children of Israel that if anyone Killed a person not in retaliation of murder, or (and) to spread mischief in the land- it would be as if he killed all mankind, and if anyone save a life, it will be as if he save the life of all mankind. And indeed, there came to them Our messengers with clear proofs, evidences even then after that many of them continue to exceed the limits (by doing oppression unjustly and exceeding beyond the limits set by Allah committing the mayor sins in the Land!

EPIGRAPH

I have always wondered why a man follows a leader obsessed by doing wrong to humanity, ignoring the fact that everything in this world has a price. After the leader attains high position, money, and power, families are then forgotten and rendered to starvation. People like Osama Bin Laden have a way with words to convince followers or "workers" to commit acts of terrorism offering a "reward from heaven". In the end he uses poor Muslims or financially unstable people who were not even Muslims; offering money for them to distribute to their families after they commit a suicide attack. (2001)

I respect mothers who sacrificed their lives raising their children, watching them grow, just to bury them at a later date because of war. They die as "heroes" but no medal would suffice to replace the life of a soldier, a son, or a daughter. We often see children lose their lives from acts of terrorism. The attacks in the markets of the Middle East, or the incident in Oklahoma City, serve as good examples. We also forget that many children die from "unjustifiable attacks" in which missiles or stray bullets rain down upon the homes of civilians by accident or mistake. (2002)

We consider our children as our future, but most have been killed because of war. Yet if they survive, their spirits have been torn apart, broken. (2003)

Searching for the truth of what Islam was on the regular western libraries was almost impossible to me, they always tried to direct the information into killings, rights of men, and polygamy, like if it was a subject read only in the Quran when in fact polygamy is a subject that was originated during times of the Bible, which is what distracts people from wanting to know about Islam as a Great Religion and

they always forgot to mention the rights of woman in Islam making anyone to have free will, which was what liberated the woman from the Christian idea of been Eve's fault that Adam was tempted. (2003)

I learned that all the answers that any human being might have are enclosed in one book, The Quran. Life was made with a purpose but we need to find and understand that purpose. I really believe that the only way to save our existence is to do what the Lord, The Creator, has commanded us to do through his messengers and books, which was to love and please him before anyone while loving one another. However, human beings are self-centered. Like barbarians, we only want to fulfill our own vain pleasures by whatever means in order to attain power. I get sad every time I think that some people have the misconception that Islam is a bloody path, an excuse to wage war against humanity, or hurt any human beings. I also feel sorry for the people who hurt women and children quoting the words of God because suicide is a sin. (2003)

Allahu Akbar translates to "God is the greatest". How then can anyone believe that an act like suicide, which he condemns to the fires of hell, be associated with his name while performing a sin? Disappointment overwhelms me every time I hear an interview that makes it appear as if Allahu Akbar means "confrontation". Although, such phrase is not meant in an ill mannered, when they mention those words while committing such horrible acts they actually poison the minds of people into believing that the phrase is actually associated with an attack. (2003)

There may be some evidence of hope as some people are learning that Allah actually means The Lord, the same Lord who created heaven and earth. What many don't know is that The Lord gave us an opportunity with Islam to create better laws not to mention the ones that protect women from abuse at the hands of a man. Although such laws are created we still see how some men

apply the old law to excuse their acts of using their women as punching bags to dispel their frustrations. However, they will pay the price on the Day of Judgment. (2003)

Many people have asked me if I needed to cover my hair even when I am asleep. I used to have that same misconception until I decided to read Islamic scriptures. I got some wrong information from a book I bought from a bookstore before I converted to Islam. I eventually learned that the hijab is only to be used when you go outside the house. My advice is READ, the right books, study, and search for the truth; that is what gave me the peace I have now. (2004)

PREFACE

When on October 2, 2006 a gunman entered an Amish girl's school in Pennsylvania and killed many, the focus was more on the Amish families than the man who committed the horrible act. The man's background was not publicized for long and soon after a film was made about the event. The movie highlighted how the Amish families visited the widow of the gunman and forgave his actions. They forgave because they accepted that it was the will of God. Of Course this person was not a "Muslim Terrorist" just a person not associated with any religion.

After deciding to publish this book on the ten-year anniversary of September 11, I decided to retract the book from publishing. I was under the impression that the general population already knew what Islam was and the underlying theme of the book had lost its meaning. I kept thinking that nobody would be interested in reading my memoirs or "my journey" to find "peace" on a controversial religion.

Simultaneously the Boston bombings occurred and like a whirlwind of flashbacks I was brought back to that frightful autumn day in New York. The manner in which the news and reporters spoke about Islam and Muslims only clarified the perception I thought that we as a nation had surpassed.

Once more I felt the necessity, like many other Muslims, to give and idea of what I found in this religion while I was searching for my peace. During my journey I learned that Islam is a way of life and a Religion with The Quran as a guide. I also realized that the terms extremist Muslims or terrorist are thrown into the public for digestion, but the problem is that if society refuses to see the reality of the issues by making excuses or ignoring that which happens

around them, then a solution will never be created. Perhaps many will never be able to know because we must face the times and whatever happens is the will of God.

I learned that the person who reads the Quran is a person who is looking for knowledge in his religion. By seeking such knowledge in a desire to be closer to God and make him happy, such a person is living the duty of every Muslim. What makes me realize is that by seeking to terrorize or kill innocent people such a person is not doing what Allah has set forth in the Quran. Therefore, by claiming to be a martyr the individual is acting against the definition of a martyr; they would not be trying to commit suicide or hurt other people. If a man is trying to follow the Sunnah or life of the Prophet Mohammed, as stated in the Quran, then he will know that it is unlawful to kill innocent people.

Questions came to my mind: who are those people who call themselves Muslims but seems like they enjoy killing people? How they look like? The appearance of a Muslim, as ordered by Allah, is that the female covers her hair and intimate parts while the male grows his beard, if he can physically, however if we see Muslims with bears we immediately think they are extremist. Some may argue that everyone is free to judge according to their personal beliefs or knowledge of certain circumstances. For example, the Amish wear beards, bonnets, and traditional conservative clothing but when we see them we don't think that they are extremists. We address them as what they are, religious people. Of course Amish are not going around terrorizing people because they respect their beliefs also they don't have anything that any government might want like oil per example.

The prophet had stated that all Muslim males were to not cut their beard and let it be. Therefore, a Muslim must not only be merciful also should be an example for others. I sometimes wonder if the terrorists were so interested in following what is in their view

the demand of Allah, as stated in the Quran, why then some of the people who commit terrorist acts in the USA like those in Boston Bombings did not wear beards? Why is it that some of the Muslims whom I see in the TV complaining of their countries don't have a beard? Why are many of the terrorist's young people? However there are today many divisions in Islam, which might confuse a new Muslim. Prophet Muhammed (saw) predicted that Islam would be divided into seventy-three sects today; we can see how Islam is divided and misconstrued.

Very interesting things that I learned from my search, especially one that I never thought about; do we have terrorist groups in The United States? Thinking in how beautiful is the bubble in which I live I search for that answer finding that not only The Muslims have terrorists also there are many terrorist organizations in the United States* like many other countries, but many people don't think about that or know for the matter. After any terrorist event people automatically presume that a Muslim is behind it all.

When some Muslims come to the United States they cut their beard that may result in the idea that the use of a beard is strictly for fanatics. Therefore, if a man were to wear a beard he would be investigated as a possible terror threat. Who's to blame here? The question that lies is whether following a religion to the point that an individual excludes themselves from western social habits is considered terrorism?

Some people claim that are Muslims while going to clubs, drinking, and disobeying what their Lord sent. The people who blow themselves up, and possibly others, in the name of a religion or a Prophet that they never respected. Many of these people who probably were looking for a "place" into society and went from the extreme of been a trouble maker to find that "peace" understanding Islam the wrong way, those are the ones that change the Religion and the word of God. Everyone is surprised later when they heard in the

news about the person they knew as a "calm" neighbor turned out to be an extremist. However, do those people know what a Muslim represents or believes in? Do they know that Muslims cannot kill innocent people, people that are not even in war, in the name of Allah? Do both parties even really know what a martyr is? What is the difference between a Muslim and a Terrorist? Why the Quran came? All this questions I had after September 11, 2001.

The Quran was made as a guide for mankind. We can read about the stories of Prophets, the battles, instructions for everything, and many other things. I learned that a person cannot get a copy of the Quran and say that they understand what it means unless they learn the story behind the life of the prophet his companions who are consider the best of the nation an example to follow, and how according to the necessity Allah sent the verses of the Quran as instruction. We cannot say that Allah wants everyone to start shooting and bombing people. How can such people say they know about the history behind of what is read in the Quran? Consequently, when someone claims the knowledge they do not have it is the other individuals in the religion who pay. Such actions hurt people, the religion, and the individual because they are misrepresenting the religion and themselves.

After many things happened people start remembering things that could be used as a "red flag" on a neighbor, coworker, or family member. My opinion is, let's not wait until is late. As members of society we should consider looking at another culprit instead of blaming Islam. What if is all Political interest? What about mental health? It should be clear that any individual who misconstrues for the purpose of destruction is not clinically sane. Perhaps the blame lies within us as members of society for being near someone who may be perceived as mentally unstable, yet allowing them to continue without raising concerns to the proper authorities.

I - WHAT TRIGGERED ME

New york City, New York. 1983

CHAPTER 1

LIKE ANY OTHER PERSON

Bismillahir Rahmanir Raheem

In the name of Allah, the most gracious and most merciful,

As salaam Alaikum

Peace be upon you

When I heard these words a few years ago, I probably wouldn't have said anything. My mind would have been blank and my heart quiet. I was not wearing a *hijab*, or headscarf, three years back.

I was more interested in the next perfume that Estee Lauder would release for the upcoming season even though I was submitted to using the "Private Collection" from the same brand ever since I was fourteen. I would also be more concerned about the fashion forecast for the next season, what color was going to be "in", or what make-up matches the clothes I was wearing.

At the time I was an Army wife working for Catholic Charities and loved my job that entailed being around immigrants. Although I was a person who loved to help people of different nationalities, I must confess that I worshipped fashion even though I didn't know that I was.

Today, my way of life changed drastically but I still believe that there is one God who created the heaven, earth, angels, animals, and humankind. I still believe in the reality of Adam and Eve, Moses, Abraham, Ismail, David, Jesus, son of Mary, and many other messengers of the Lord. Best of all is that today I am a little more educated or at least a little bit more I shall say. Well, at least I know that Mohammed is not considered a God and that *Allahu Akbar* does not mean "attack."

I must mention that today I am a Muslim. As a Muslim woman, I found the religion that set me free. The way of life that finally gave me the peace I was looking for and the religion that allowed me to have the rights, as a wife, which I never saw in any other religion. A few years back I decided to change my life. Today, I can finally say that I am very happy of having Islam as my way of life.

2003-IDENTIFYING THE UNKNOWN

You see her walking in the streets, perhaps in a mall or in a store - a woman covering her hair. She is Muslim and is approached by another Muslim. You begin to get nervous. After all, you never know when another killing spree might happen. As you hear them say some kind of a greeting, you feel the urge to run for your life. Your heart begins to tremble and you ask yourself, "Is this a sign of an attack?"

As Salamu Alaikum had become a phrase too dangerous to utter these days especially around people who didn't know its meaning. Don't be afraid when you hear it because every time we see other Muslims, even without knowing them, we must greet each other with these words that mean *peace be with you*.

Nowadays, when I hear the words *As salaam alaikum*, my heart jumps for different reasons. My mind is in a state of peace and relaxation for these words tell me that I am in a safe place with benign people. They tell me that I am around Muslims. They also tell me that I am no longer alone because whenever I move from one city to another, in any part of the world, I will always have a Muslim family or a sister near me.

How do I start my day? Before Muslims begin doing anything, we first say, "In the Name of Allah." Is this something bad? Is this a sin? Can these words hurt anyone? It simply means *In the Name of the Lord* or *Bismillah*.

Believe it or not many people get terrified because they get all the wrong ideas when they hear the mere utter of the word *Allah*, who they think is an idol that someone invented. What some people don't realize is *Allah* is a word in Arabic, which means *God* or *the Lord* in English.

However, there is no translation in English that can describe the meaning of *Allah*, so we use "The Lord" because it is The Lord that created the Universe. Hence, it is important to clarify that *Allah* really means more than the term "Lord."

I began a speech in the Islamic Center of Clarksville, Tennessee happy to be part of the enthusiasm that pulsed around the center. After waiting for almost twenty years, the local Muslim community finally had a place to pray the Friday *Jummah Prayer*. All praises be to Allah, we finally opened our first mosque, which brought new ideas for activities to be hosted at the facility.

The wife of our committee director suggested a project that would involve all our women; it was a project that would benefit many people in our military town, since many of the converts were family members of those in the service. She conceived the idea from

the "First Women's Convention." We wanted our neighboring communities and friends to come together in "Peace Through Knowledge," an event that educates other people from different beliefs to learn similarities between our religion and others.

We wanted to inform people about Islam and what made some of our former Christian sisters learn which eventually led them to convert to Islam. Why not? After all, we see each other in the streets, in the park, at work, or doing business around town. The convention was an opportunity to clarify misunderstandings about Islam. A creative way to focus on our faith together, with people of different religious background, who believed in the same *Lord*, the one who created the Earth and everything around us.

SHARING WITH OTHER RELIGIONS

Clarksville, Tennessee is what I consider a military town; a small city where the majority of the population are Christian. Tennessee is considered part of the Bible Belt[1] thus it is normal to see many churches in this state. Clarksville, which is also near the Kentucky border, is an hour drive from Nashville. In the surrounding area just along the border, there is a military base that is home of 101st Airborne Division. The base, Fort Campbell, is so vast that one side of it is actually in Tennessee and the other in Kentucky. Rarely would you see any Muslims walking around the malls or doing groceries in the same manner you would see them in much bigger cities like Nashville, Detroit, or Chicago.

[1] The Bible belt http://en.wikipedia.org/wiki/Bible_Belt

By the time I had become part of the local community many Muslims had already moved away before the opening of the new mosque because there was no place for worship or prayer. They moved away because there is a need for men to pray the *Jumah,* or the five daily prayers. There was a need for a central location for families to gather and pray as a community and there was a yearning to spend time with others who share the same belief. We wanted to gather in peace, just like people in other religions; that is what Islam is all about, peace.

Islam is a way of life that means submission to God. Thus, it is very important to be surrounded and spend time with other Muslims. Many of them had to drive for an hour just to pray *Jumah* on Fridays, which for some, especially those who worked in Clarksville, was almost impossible to do. Our first official convention was a success. Many attendees came from different towns and they invited co-workers, friends, and families. Despite the war in Iraq and all the misconceptions that the media generated about Muslims, people met and congregated in "Peace Through Knowledge." One of our sisters, a United States Army veteran who converted to Islam eight years back, came up with the name of the convention.

Among one of the most important topics was the "History of Religions," discussed by a sister who was a middle school history teacher. She started her speech by pointing out things that many people are not aware of; as a history teacher this topic was her expertise. She presented the truth about a time in the past that despite being part of history many people did not know about. Perhaps it was for their lack of interest when the subject was taught in school, or perhaps they needed a little review, or maybe their teachers simply did not touch or expand on the topic.

All the sisters presented very interesting topics. Our stories of the prophets [may peace be upon them all] were one of the most emphasized similarities that our religions shared. Such

prophets include Noah, Moses, Abraham, and Jacob. We also touched the importance of Jesus [peace be upon them all]. Above all, we talked about whom Prophet Muhammad is [peace and blessings be upon him]. Another sister spoke about women's rights in Islam a topic that was specifically chosen to clarify that notion because most people think that Muslim women have no rights. The conversations clarified many misconceptions about Islam, which was one of the main objectives of the convention.

The last to speak was a sister whose husband served in the United States Army and was stationed in Iraq. She explained how Islam changed her life. I spoke as a newly converted Muslim and as a soldier's wife. I converted to Islam three years before that time. I did not feel nervous during the convention even though I was not fluent in English. I was there to talk about my conversion, and of course, the things I liked about Islam.

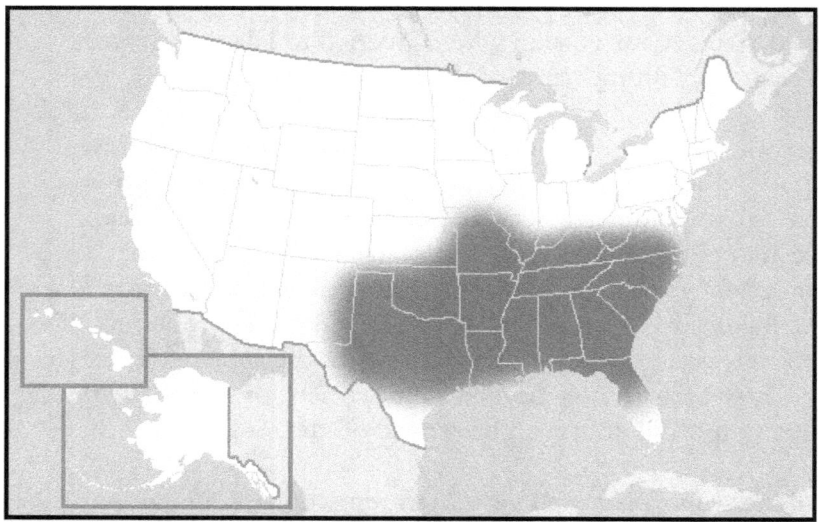

Image of the Bible belt in the United States.

CHAPTER 2

OUR DESIGNATED RELIGIONS

I thought about how I was going to keep the attention of those in attendance at the convention. I wanted them to enjoy everything in the speech while being myself. After all, even today I am still the same person I was before I learned about Islam, just with a moderate voice. This is how I started my speech:

"My name is Cardona. I am from Puerto Rico. My [native] language is Spanish and I am not from the Middle East. In case there's a doubt and if anyone is wondering; I'm not sweating with this scarf on my head."

The audience burst into laughter after that introduction. I looked around at everyone and could see several audience members using a piece of paper or any item that could be used as a fan to provide a cool breeze. Spring was biding farewell and the humid southern heat was creeping in our day-to-day lives. Satisfied with the introductory result, I continued with my speech:

"It's a pleasure for me to share my experiences with all of you about my conversion to Islam. First, I would like to introduce some words that are very important to the people that are speaking to you today. Before we begin anything, like driving, eating, or reading, we say, 'Bismillah', which means "In the name of Allah" or "The Lord". Every time we mention any prophet we always mention the words "peace and blessings be upon him" out of respect. When you hear the word Hijab, it's this scarf. If we say: "Alhamdulillah" means "All praise be to The Lord". When we say, 'Inshallah,' it means, "if Allah wills it."

"I should start by giving you an idea about how my life was before I embraced this beautiful way of life. I want everyone to know that before my conversion to Islam, I visited many different churches throughout the years, but I never felt my heart completely full or happy. If I felt anything, it was only a temporary happiness; a religious fervor that a person feels after listening to a sermon in Church. Suddenly, a very sad moment came to my life; a moment in which I had to go to my home country because my father was dying. I was scheduled to be baptized in a church that coming Saturday. During the time in which I was in my country something happened to me. I had time to reflect. Perhaps listening to the services offered or maybe the time spent at the funeral, I realized that I was not ready to be baptized as a Seventh Day Adventist. I had many questions, but they were not answered.

Fifteen years later, I was baptized as a Mormon, which also did not fill my heart with the faith that I wanted because before that time I had met Muslims. I had the opportunity to spend time with a family. I loved their way of life. I wanted to be Muslim but I am not a person who likes to ask many questions, therefore, I thought that I had to be born in the Middle East to be Muslim. A thought that made me live in ignorance for a while.

Trying to get information in local libraries, all I found was that they could have four wives, which made me think that it [Islam] was a religion for Middle Eastern people only. Which shows the lack of information I had, like many other people. However, I learned that "Allah" was a word in Arabic and that the translation meant "The Lord".

Such information wasn't convincing enough for me since I thought that I was not allowed to be a Muslim. Sadly, I decided to abandon the idea and convert to Mormon because I thought they had a similar way of life like Muslims. I was looking for a way of life after all. I thought there was no harm since the Bible teaches the same thing to

everyone. When I was baptized I told myself, 'God forgive me if I'm sinning, but if I cannot be Muslim I will follow the Mormons.'

The Lord works in mysterious ways because it was not until 2003, after I was already a Muslim, that I started to look for evidence to support the things that I wrote. When I learned about polygamy, to my surprise, it was not Islam that began polygamy rather that it started during the times of the Bible. The laws were so severe for women that when the Quran arrived, it fixed the bad laws and removed the injustice. I learned that Salomon used to have 300 wives.(In the Bible, 1 Kings 11:3, it is mentioned that he had 300 concubines and 700 wives) 4)

I liked the way of life of the Mormons. The way they helped and respected each other. However, I was not ready for the Joseph Smith belief. I always thought that is very strange how we came to life with a designated religion for us. Long ago I decided that I was going to teach my children about God, but I wanted them to find their own belief or religion just like they had been raised. Free to choose. I took them to a church, but if someone invited them to visit another church I would allow them to go. The surprise came one day when one of my sons asked his father and I if we had any objection for him to be baptized Mormon. I researched al the information I could find about Mormons and finally we agreed. At that time our family were members of the Catholic Church, but our son always complained and never wanted to go. My husband and I decided to let him be where he felt happy as long as he believed in God.

One day, when we traveled to our country, my son received a visit from the[2] Elders. I had a conversation with them and told them that I was not happy with my religion. I had many doubts and I was not feeling the peace that everyone should feel. I wanted to congregate in a

[2] *http://en.wikipedia.org/wiki/Polygamy_in_Christianity*

place that gave me happiness not just the momentary feeling I had felt when I went to the church. I wanted to feel that happiness all the time. The Elder smiled at me and told me that the same way I was feeling was how Joseph Smith felt. He was looking for his place of congregation when all was revealed to him.

I felt that I had something in common with Joseph Smith, yet it was not love at first sight. After my conversion to be a Mormon, I was confused and concerned. As a result, I was not happy. How could I feel Joseph Smith in my heart and think that he was who they said he was? The Elders advised me that if I prayed every day, he would come to my dreams; it is very important that if I am a Mormon I believed in Joseph Smith. So, I prayed every night. I tried very hard and finally I stopped visiting the church. The Elders came to my home and I told them, 'I am very sorry. I prayed every night but Joseph Smith never showed up in my dreams.' "

The people in the convention laughed at my statement. However, it was not my intention to make fun of any religion and I certainly disapprove of people who do. A person's religion, or view, is to be taken seriously and I didn't want to disrespect anyone. In the same way, I don't want others to disrespect my beliefs or any of the prophets in it. I view Mormons as one of the best, organized churches I have ever seen. The way members care for each other is truly amazing. They have a food bank ready to help members in need. They also care for the single women. If they don't see you in a couple of days, the Elders will be looking for you to see if you are okay or if you need anything.

One morning I woke up to someone outside cutting my lawn. I was not able to mow my lawn for weeks because I had been sick. The Elders help people in need and that is REAL brotherhood. The comradely I had always read in the bible and the unity that Jesus envisioned for mankind. Mormons don't wait for you to ask for help

or tell them your needs. They know how people tend to feel embarrassed by asking and thus extend their help voluntary.

I admired that way of life. I had been looking for the kind of people who put in practice what the Lord ordered us to do. I was not able to see the same treatment in other churches and so the Mormons captivated me. However, something was still missing. The void I had been feeling was only filled when I fell in love with Prophet Mohammed [peace be upon him].

When I learned about Prophet Muhammad, I felt that he could be the one prophet mentioned in the Bible. Later I found an answer that he was a descendant of Ismail, son of Abraham. I spent my life looking for the religion that answered all of my questions and gave me the congregation I needed since my faith in the Lord grew more and more every day.

The time came for me to find my congregation, but after studying different beliefs I always reverted to my Catholic roots. Such relapse was normal, since it was the religion that my parents taught me. In fact, it was the religion that felt "normal" for me because I was raised Catholic. One day my friend told me how we were all born without a religion and how we naturally choose the religion our parents teach us. When my friend gave me such insight, things began to make sense.

When I finally finished my speech I kept thinking about how nice it would be if other people could learn or hear about this information. I wanted more people to know about my conversion and the process that I went through. I wanted to tell my story to millions of people because I knew that many people out there probably went through the same pursuit for the truth.

In order to talk about Islam, one must be a person who is well informed about the religion. One must possess the knowledge that I

don't have since I am still learning. I only decided to tell my story. You are not going to find much about Surahs of the Quran. Only time a Surah will be mentioned is if I am trying to support what I am stating in order for you to understand how the topic made me feel or what motivated me to join this different religion.

I wrote my experiences as a woman looking for the kind of religion that would fill her existence and serve God in the best way she could. I was not looking for perfection in religion because the word of God is perfect, but we mere humans are not. We are free to choose our own path; however, I have always felt that ever since I was born, someone had already arranged mine.

The pages in this book do not follow a specific sequence. Don't expect to find detail arranged chronologically. My thoughts and ideas flow randomly in this book, and I intended to present my ideas candidly for a reason. You might say that there is a method to the madness. In the next few chapters I want people to find valuable insights about what made me have questions, doubts, and also share with you my background before I converted to Islam. It's easy for a person to jump to conclusions basing their information from what they hear in the media.

Oftentimes the media only shows what terrorists or non-religious Muslims are doing. I used to have many Muslim friends when I was lost and looking for that something that was missing. Many of them were very good people. They donated to charities and went to the mosque, but I also witnessed them doing things Allah forbade. In Islam the relationship between an individual and Allah is something between them, so I cannot really judge anyone because I am not Allah [the Lord].

However, I must cautious if talking or listening to someone is going to affect me with my beliefs or if is going to affect the reputation of other Muslims. There lies the difference of Muslims.

For example, if I am a Muslim and I am going to a bar then people will judge all Muslims and will be confused of what Islam stands for.

Before I converted to Islam I used to see people, myself included, urged to make others happy; be it our children, husbands, parents, and friends. I remember how during Christmas we try to fulfill their wishes by buying them presents. All the while, the last person we take our time to please is our Lord when we should please him in the same manner as we please others. The desire of making him happy is what I call *love* and *submission*. Thus, if Allah [the Lord] asks us to do something, we should do all we can to please him; that is how we submit ourselves to him.

Many people like me had doubts because of the lack of having proper information. This is why I am giving you an idea of how my background was and what lead me to convert to Islam. I wanted people to accompany me in my journey of finding peace through knowledge. I am still discovering more things, including the information I needed to feel his presence in my life in order to worship him and to fill my existence with happiness.

THE DAY THAT CHANGED THE WORLD

*E*verything started to happen after September 11, 2001. On that particular day, I was serving my husband breakfast while the news was playing in the background. My daughter was already dropped off at school. Suddenly the regular news program was interrupted and the first shocking images of an airplane hitting the World Trade Center were broadcasted in front of our eyes. My initial thoughts were that the air traffic controller must have fallen asleep on the job.

After we saw a second plane crash into the twin tower, terror began to overcome every fiber of my being. "OH MY GOD!" I yelled to my husband, "We are under attack!" My husband responded, "No, I think those are terrorists." The first thing that came to my mind was the people. *"Oh My God! Please don't let anyone die!"* I thought to myself. Desperately hoping to be wrong I asked my husband, "Do you think anybody died?" Yes, I know it's a silly question, but I asked anyway. He looked at me with an expression of disbelief.

I guess the way he looked at me was more like the expression of a soldier who has served in the Army many years. He was rather surprised that a military wife would ask such question. A military wife who should have had the same conclusion about the events that were unfolding on screen. "Only a miracle could save those people," he answered. In reality, it was the response of a person who wanted to cling to hope or someone who desperately wanted to wake up from a terrible nightmare.

I couldn't help but panic. I thought, "Oh my God. If we are getting attacked, then they must also be after all the military bases!" Anxiously, I pleaded with my husband to get our daughter from school. I had a hard time sleeping ever since that day. My husband assured me that we were safe. The idea of being thrown a bomb while sleeping ran through my thoughts as I would lie in bed. I no longer felt safe inside the military base. I thought about my family living in New York.

My sister told me that she was going to the beauty salon that day and I imagined that the salon was inside or around one of the towers. I thought about my nephew who fixed elevators in Manhattan. Perhaps the only one, who I felt was okay, was my niece since she lived in New Jersey at the time. I tried to call them, but the phones were not working. By that time, both of the towers had collapsed to the ground.

After several desperate attempts, I was finally able to get a hold of my sister that afternoon. She said that her son's car was stuck on a bridge when all the events were unfolding. "The traffic was at a complete standstill," she said, "and he was giving a ride to one of his friends who was a fireman." However, she had no knowledge of the whereabouts of my niece. When I learned that the people behind the hijack of the planes were terrorists and Muslims, I just simply couldn't believe it.

The image I had that Muslims were peaceful people was shattered. I must confess that I had mixed feelings and was thoroughly confused. Afraid of all my questions, none of my Muslim friends answered their phones. They felt mortified and embarrassed because in the name of the religion that they tried to show the world as peaceful, thousands of lives were lost. Majority of the people I knew were Muslims. I always liked their religion and decided to start looking for additional information about Islam.

Meanwhile, things were getting chaotic at the base and a feeling of paranoia crept into everyone's homes. Being the military families that we were, we felt that conflict was imminent. All the men and women of the army would be called for duty. What transpired was not something that the government can just fix with diplomacy. My husband sat with all of us and he explained that something might happen. He wanted us to know what to do in case he had to leave.

I counted the hours for my daughter to arrive from school every day. I hated going to pick her up because I did not like seeing the soldiers on the school rooftops armed with M-16s, ready to pull the trigger. One night, my husband received a phone call. He had to go on an emergency operation. We all expected something like that was going to happen and that it would probably be bigger than Operation Desert Storm.

THE YOUNG SOLDIER

I cannot forget the last day before he left for Iraq. He met with all the soldiers outside, with their families and equipment. The units arranged some refreshments. That day, the family members of servicemen were gathered to see them leave for Iraq. Nobody knew that the war would begin with that first wave of soldiers that left.

I remember seeing a young couple. The husband was around the same age as my son, eighteen. Just like my son, he too was married, but the couple already had a baby.

I remember that I took a picture of him with his wife and how I felt sad at that time. I asked him: "Why would a young person like you be sent to Iraq? Why would young people join the army instead of attending college?"

I sobbed when I saw the soldiers leave, but more than the fact that they were leaving, I cried because that young soldier reminded me of my son. I kept his image on my mind for days. I prayed for all of them, but mostly, I prayed for him and all the other young soldiers like him to come back home safe.

One night, I was called by one of the soldier's wife. She wanted to know if I knew how her husband was doing. I knew that something had happened, but I tried to take my mind off the news. Later that night, my husband called me. He told me he was okay. He also told me that they lost two soldiers and that I might have to go to a funeral.

A few days later, I was prompted to go to the funeral without knowing who died. My husband did not want to let me know. He knew how I would react. Despite that, I felt sad over the fact that a

life of a person was lost. The solider was a son, a daughter, a father, a mother, a brother, a sister, a wife, or a husband.

The funeral was held in a town two hours away from my home. When I arrived, a Sergeant Major, who used to be my husband's boss while stationed in Germany, was waiting for me. He wanted to know if I brought the pictures that I took before they left for Iraq.

I gave him the pictures he wanted to see. Right there and then, he identified those who died from the pictures he selected. In an attempt to control my emotions, I went inside the funeral home. My heart was filled with tears and I offered my condolences to the widow, and one of which was the young soldier's wife. The photo that I took was the last picture of her husband before he left for Iraq. The young soldier, with a baby and a wife, had died when a grenade exploded in his hands.

Ever since I was a little girl I always thought that scientists should have created an antidote to change the world. A world in which there existed no wars, but that was wishful thinking. I also remember daydreaming of someone inventing a time machine where we could just travel back in time and change things. Of course, it remained just as it was...a mere dream.

CHAPTER 3

THE OTHER WITNESS OF WAR

*E*verything happens for a reason and everything plays out in accordance to the will of God. Witnessing death played out in 2001 only reminded me of my deepest fear and added to my memories of the Vietnam era. At the age of eight I was afraid to lose all the people that I loved and was most definitely afraid of my brother being drafted. Now, as an adult now, things haven't changed much. I am still afraid. Afraid of losing the father of my kids, my children, or the neighbors that I knew had children. The only thing that has changed is the way in which we are connected and communicate. Instead of being a spectator, now we are like actors in a real life movie. I still have the same feeling as when I was eight.

I still feel the same way about wars, now more than ever. Not only because I am married to a soldier assigned in Iraq, but also because when someone walks inside a base one can feel the aura of death. Such feeling is especially evident when you walk or drive around the neighborhoods on base. Windows of houses that were beautifully decorated with reminisces of life some weeks ago are now empty. The heart begins to sink once you remember that neighbor who once waved at you while you drove by his house. Perhaps the heart sinks because of the realization of why the window is now empty.

The base feels and looks like a Ghost town. Uniformed personnel now occupy long lines that once formed and were a common occurrence in the grocery stores. The scars of the war are even more prominent with a visit to the hospital. You may arrive at the entrance and pass a young soldier wearing fake legs and the

handicap parking spaces that used to be semi empty are now always full.

Like I mentioned before, I needed an explanation or truth behind what everything was. I wanted to have peace in my heart. Reading the bible gave me that peace but not the answer I wanted because the people who committed those crimes were Muslims.

I read the Bible, but never found answers to questions that ever since I was a child kept haunting me. I was confused because whenever I read the Bible it was clear to me that God wanted people to live a different kind of life, yet I never saw anyone take into consideration what the God in the Bible wanted for mankind.

I wanted to change my life, but I wanted to see the people in my church do the same. I wanted something different, not only going to church, repent, and still lead an empty life. I wanted to have brothers and sisters sharing my beliefs and people respecting each other as members of that community. I wanted people to serve as examples for others.

Yes, as an eight-year-old girl I thought that a time machine could change the world, but that was a wishful thinking. I am an adult now and I know I can't change the world; however, at least I learned that everything in this world has a purpose.

I know that only a few people can actually change their way of seeing things, and I hope they can really change. I hope someone could at least reflect about their life while reading this book. I am not trying to convert people to Islam, as only God can do that.

Let me reiterate. The purpose of this book was to tell the story of someone who used to have all the misconception about Islam that are currently present in society. Perhaps the questions that arose during my adolescent years are what prompted me to look for that

certain "something" and a "way of life" I felt we needed. I know what has been taught in the sacred books that no one pays attention to. The Lord decided to send a different book, the Quran. Perhaps this time, people might understand what he wanted man to become.

LEARNING + FAITH = SUBMISSION TO GOD

When Islam came into my life, I was at a crossroads at which my heart was longing for change. On one hand, he [the Lord] ordered me: *"Let go,"* but on the other, I responded to myself: *"Are you crazy? I love fashion, makeup, alcohol, dancing, Halloween, and I can go on and on!"* Many questions and a roller coaster of emotions overcame me.

"Do I really want to change those things? I felt great whenever I'm around them. I'll learn things that make sense, but can I celebrate Christmas at least? If they don't celebrate my favorite holiday, then no way!"

I did want to change my way of life. I wanted to feel peace, well, I felt God in my heart anyway. In other words, I did not want to get out of my comfort zone. I didn't know if changing my life as drastic as that was what I really wanted. Is that the same reaction a person gets while visiting a church? Does he feel or hear the call of God? What about when the pastor says, "If you accept Christ, then come here in front!" When a person feels, they do not think or use intellect. They only use emotions. The person only lets go. Of course, being Christian is "normal" in Western society.

The same thing happens when some people learn about Islam. They may feel the seed of peace in their hearts yet rationalize instead. One may say, *"Wait a minute! This is a strange religion. I am not going to*

cover my hair! This is a religion for Arabs. Those people don't have feelings! They kill, and do other nasty things."

We repeat what the media has informed us of or perhaps what we read in books written by someone who probably escaped from a nation ruled by a dictator. We act upon what we hear from others who felt miserable in those countries or perhaps from people who didn't seem to understand that everything happening was because of the will of God. Perhaps such stories derive from women who didn't even bother to wear the Hijab because they didn't believe that wearing it was one of the commandments of Allah.

Those same women might have seen it as a government mandate or a part of *modernism*. I want to make clear that Islam means submission to God. I am talking about Islam and what is written in the Quran, not of someone's interpretation of the Quran. I am talking about the religion that is not ruled by *compulsion,* the way Allah prescribed in the Quran. Some books denouncing many of the atrocities that someone has been a witness of are real stories. Those are real experiences or trials of someone who knew the Quran by heart but probably did not apply into their life. What can the world think of a person that is Muslim but drinks alcohol like in one of the books that I have read in the past? Perhaps maybe the person is depressed? Can people that know the Lord and are submitted to him feel depression and not be cured?

What I see is that many of these people that drink and party are born into the religion. Yes they may make prayer or maybe they know the Quran by heart, but they are not religious Muslims. A religious person is one does not give up easily when problems arise. These are the people who know what the Lord wants from them. Therefore, they are going to take all the suffering in their life as if it were normal only because Allah sent the calamity for an unknown and they accept it with conformism. Being a Muslim submitted to Allah is the definition of Islam. If we think about it submission is not

synonyms of extremism. When a person is an extremist they are taking one side more than the other, therefore, that is not Islam because Islam is a religion that you cannot take one side or the other. Islam clearly states what Allah wants from any Muslim in a steady way and Allah hates people who like terrorizing; or people who only think of their own gain.

Many people have questions and doubts when they get attracted to Islam. However, once they learn about the religion, they see the truth, and it makes sense.

Other people, upon feeling it in their hearts, reevaluate it: It sounds like the truth…but…what about my family and friends? They will certainly stop talking to me. Maybe they will get all the wrong ideas about me.

Can you imagine how my life was after I converted to Islam? I finally felt free even though I was working in Catholic charities, always around Nuns. But, is it what God wants from us? Does he really want us to question him after he puts that seed in our hearts and in our souls?

I believe the moment Allah speaks to us and makes our hearts at peace is when we should feel comfortable to let ourselves go and submit to him. When that moment arrives, you no longer care about your looks or the holiday you would be missing as long as you are doing it for the love of God.

Now, I had a legitimate reason to study Islam. I had many questions while growing up and I had even more questions after 9/11. Since my adolescent years I had always studied some of the religions. After all, I always had the urge to go back to the old way of communicating with God. Pray alone in my room. Could it be that this change of religion was a result of not having a proper kind of upbringing?

Well that may be a reason. Yet the reality of it had always been the prevalent emptiness that some people feel after they go to a service. They feel great that day, but the next day is another story. They go on living an empty life. Why is that? I had the feeling that religion was not just about praying to our Lord, or going to church. I felt that we needed to do more, because after we learn so many things, including loving one another, why do we still feel the same? The truth is that many people feel happy going to a certain denomination because it's an attempt to feed their needs as religious people and in accordance to the way of life they prefer.

My mother used to say: "I like the church that I'm visiting because I can put make up on." She was of course joking. She was never really baptized in that church.

If you ask many people what they like about their church, they may tell you they like the people or that they've been going there since they were little. We are like zombies. We do what we have been taught is good and sometimes fight with others about a religion or book that we are not cultured in. Therefore, it was not a surprise to me when I asked someone who was trying to argue about for a specific theme that was written in the Bible. The person confessed that she never read the Bible. Some people tell me, " Well, I go to that church because it's a church. I don't care where I go as long as it is with God." If you think about it, religion is not subject to only one order. We have many others. What about one of the most important commandments in religion? What about charity?

As a child, I never had the experience of going to bed hungry, yet cried every time I saw a severely malnourished child from somewhere in South America or Africa in the news. Of course I had the same questions that many of you have. How come the rich won't do anything for these people? There is only an abundance of television commercials soliciting money for them. Why doesn't the owner of the TV help them? Of course that is childish nonsense but

why don't we all put money together to finish the poverty in the world? Such illogical childish nonsense, yet, what would a child think if they knew that such money was being spent on wars.

There are many things I have witnessed as a military wife traveling around. People in dire need, begging for someone to to give them a hand or people who only ask for a little company during times of solitude. People who send money far away to help others while there are many in their local community without food on their tables. I see many people in great need, but most of them are invisible in the eyes of those around them.

If I could direct any kind of charity institution, I would give in the very same way I learned how to while my husband was in the army. I would use the famous system that soldiers use in service, the chain of command. In this case let's ask from those at home, from your church or mosques, and from the rich in our individual countries. Then, if there's excess let's help the poor in other countries. In this manner, the rich help the poor in their respective nations. I often hear the "I don't know how to" excuse from people who don't give a helping hand. Have you ever opened your eyes to see those in need? Don't even ask them if they need help. Just do it.

While I was growing up, I often saw UNICEF ads where one could see hungry people in places like Indonesia. Many people would say that there were many cows walking around in India roaming freely in the cities and towns, but they couldn't eat them because their religion forbade it. In other words, they bore their hunger because of their belief. We couldn't help them because they chose to be like that. This surprised and intrigued me, and it was one of the reasons I studied various religions.

People react according to what they hear in the news or from their families. Everyone has various ideas, but only we can change ignorance into knowledge. Reading the right books took me where I

wanted to go. I looked for information in libraries, bookstores, encyclopedias, and even the Internet. However, if such sources were from the occident the information that was delivered to you was oriented to what the society wanted you to know or believe.

I realized that majority of people follow man instead of God. They only listen to what somebody from their own religion teaches, instead of reading the writings of the prophets, inspired by God, in the sacred books.

Most people are familiar with just a fraction of the Bible, or what their leaders want them to know. Yet, if you actually ask them what their religion expects from them, they struggle for an answer. They may know the Ten Commandments or some verses from their sacred books, however, is that submission to God? Do they know anything about angels and the devil? Where he lives and how to avoid him? No. Many people are not aware of these things because they only know what they were taught. Who am I to judge? Perhaps I was looking for my identity or perhaps I was just like them.

II - BETWEEN TWO WORLDS
"MEMORIES"

Barcelona, Spain. 1982. My First son and his Father

CHAPTER 4

MY UPBRINGING

I have already mentioned my observations as I was seeking that certain "something" that was missing. As previously mentioned I was looking for peace in my heart. One thing I was sure of was that nothing in this world happens by accident. Everything is already written and has a reason.

Growing up, I was like any other child who loved to play. However, I was somewhat of a privileged child born with a silver spoon already handed to me. Or how they say on the island, "born in a golden crib." In the end none of that mattered really and I sometimes wonder where that crib went to.

My parents were busy taking care of their business most of the time and my sisters would also work in the business. My mother's business consisted of the first pharmacy to be open during the night in Santurce, Puerto Rico. While my father had several dry-cleaning shops in various towns and had a farm as a hobby. The farm had many cows, pigs, goats, and fruit trees that also provided additional income. My parents then sent two of the eldest sisters, who were in the twenties, to study medicine in Barcelona, Spain, while I was raised in a spacious house in Puerto Rico; though later I was soon to shipped off to Spain. Later in my father's life, a few years before he died, he bought a bakery. I pretty much or, at least I felt like, I derived from a wealthy family. However, I loved being around my father's employees, especially the women who washed the clothes on the second floor of his dry-cleaning shop. I loved being in their houses even though their roof was falling apart and would sometimes give my parents a hard time because all I wanted to do

was spend the night at their houses. One of my favorite houses to visit was Doña Paula's. She was a woman with dark complexion who worked at the shop and would often ask my father's permission to have me stay at her house, after much of my insistence. I played with her children day and night and she once asked my father:

"Don Isidoro, please allow your daughter to stay here. We will take care of her but you should know that we can't stop her from drinking our coffee."

It was the truth. I loved their coffee! Doña Provi, another employee, used to give me that "powerful beverage" since I was ten. They used to mix the coffee with evaporated milk, which even today makes me unable to taste of the hint of coffee. My father, as humble as he was, felt that I was abusing his employees' hospitality but he allowed me to spend the night in their homes because he considered me as the apple of his eye.

I am thankful for my father whom I learned many things. Even though he was not a religious man, as he constantly argued with the priest, he taught me that there are many people with different races and backgrounds. Yet at the end, we all are the same and must obey the same God. "After all," he said, "when we die, the worms eat your skin and they don't discriminate." I still don't know why he was always arguing with the priests. I guess he was also on a journey of peace, looking for what he never found.

He also used to say that presidents go to the bathroom just like we do and that a person who doesn't read is blinder than the blind. What made me content was knowing that no matter how hard life got, whether I found myself in economic woes or distress, I would never pretend to be anything more than who I was. We all are the same in my eyes. One day, you may experience the joy of satisfaction and the next you couldn't be farther. I have experienced it so many times in my life and I see others go through it.

While staying at my father's employees' houses, I had the chance to be with people from different religious backgrounds and learned how to sing Christian hymns with them. Their homes were not fancy, in fact, they didn't look comfortable, but the people who lived there were happy and I loved that atmosphere. The people of Puerto Rico reflect the island's rich history just with their physical appearance. Some have a fair complexion; some have a dark complexion, while some are in between. Just like a rainbow; a beautiful mix of races and colors reflecting the flavors of Spain all the way down to Africa.

My mother always had a smile on her face and was always making jokes. I can barely remember an instance in which she wasn't. If she was not joking around, she was singing. The only time I saw her act differently was when my brother died and during the last days of her life. She liked to talk and make friends. Fortunately, I had the chance to live with her for three months before she died. Now, I deem it important to let you know that I was a superstitious woman. Before I had the opportunity to visit my mother, we were stationed at Fort Bliss, Texas, at a time that many soldiers were coming back from "Operation Desert Storm." Every morning when I awoke I would hear my favorite radio station playing a certain song about a mother dying and had nightmares in the nights that followed.

I told my husband about my "intuitions" and that I was worried about my mother. Concerned about my feelings, he decided to investigate if there was a way to stay with her for a while. I kept having nightmares every night and the more I thought about her, the more I became terrified with the idea that she was going to die. As a person who used to study topics about angelic beings, I believed that angels give you signs prior to the death of a loved one. I asked God's forgiveness for it and today I am liberated. I now know that nobody can predict what the Lord has prepared for anyone. He alone knows the preordained date of our departure from this life, which he himself sets.

The idea of having premonitions, or intuitions, made me suffer throughout my life. Such idea kept me captive in fear like if I was being imprisoned and sentenced to having bad dreams of people dying or other harmful things that may come over them. Even though my mother was not my favorite parent, she was still my mother and she was the only one I had left after my father and brother passed away. My mother and I became closer through phone calls because we were not able to heal from the sudden death of my brother who was just 24 years old when he died.

My husband decided to fill out the form request[3] which all soldiers must submit and process if they want to request for a change of base. He received an approval for a transfer to Korea, which also allowed my kids to study in a school inside the Naval base in Puerto Rico and immediately sent us to Puerto Rico to be with my mother. How could I know who provoked those "premonitions"? Satan was the one playing with my mind and he did it by means of his favorite distraction, music.

[3] (Form 41, 87) is a form used to request a change of base.

MY MOTHER

I don't remember exactly how long it took for the request to be approved. The application to be based in Korea was not something that many soldiers wanted because it was a single's tour, which meant they could not take their family with them. I went back to the island thanks to my husband's understanding. The previous place where we lived was rather small. My husband later found a house that previously belonged to the Coronel and had an option to buy. The house had eight rooms that allowed all of us to live comfortably with my mother until he came back from Korea within the year.

I told my mother: "Mom, I want to spend time with you. I came here to amend all those years of distance, but remember that I am somewhat of a hermit. Please try not to bring too many people into the house. I just don't feel comfortable when people get the habit of coming to the house without asking me."

I headed for the base the next day to drop off my kids at school. When I came back, she was no longer there. She was outside busy talking to all the neighbors. She became friends with all of them in just one day! That was her personality, a very social butterfly. I loved her black hair and the way her eyebrows were shaped.

My uncle Luciano, on my mother's side, once told me that she inherited her eyebrows from her grandfather who was of Syrian and Turkish descent. He always looked at the family tree, which made such statement believable. Nevertheless if in fact such statement were to have been true, he took the evidence to the grave. Besides, I never asked him for the details even though I couldn't agree more. Never had I seen such beautiful eyebrows on a woman of any other race outside of the Middle Eastern. Sadly, my eyebrows' were not like hers. Her flawless face would visit the Mall every Saturday to buy the most expensive night creams that she would put before going to sleep.

I couldn't believe the day she was hospitalized. I left her at my sister's house and a day before I left we visited a doctor who lived in my sister's building. She told me that the pain she felt had no relation to her heart, so I left. We had become so close that she did not want me to go. She made me promise to pick her up soon. Of course, I told her that I would and left in a hurry.

The following day, a police officer knocked on the door of my house. He told me that my mother was in the hospital. I responded in disbelief, "I don't think so. My mother doesn't get that sick. She is a very strong woman and laughs at the idea of hospitals." He insisted and I said: "Look, she's fine. You don't know her. She probably couldn't locate me and decided to call the police station. She has done it before. She probably just fooled you guys."

They heads hung down, staring at the floor and I quickly realized that they were telling the truth. I rushed off to see her and my sister, who is a doctor, told me that she had one of the worst heart attacks a person could have. "They don't think she's going to make it," she said. When everyone left the room I told my mother, "Mom, forgive me for being rebellious. Forgive me for being more attached to dad and thank you for being with me these past three months." She signaled for her bible and wanted me to read Psalm 23.

After I read the Psalm, a moment of epiphany overwhelmed me and soon after the realization such enormous impact she had in my life. Her mannerisms and approach to people always made everyone feel that they were right. I never saw my mother without make up before. She would wake up in the morning and her face was already made up and was like that all throughout her life. She was always optimistic and didn't care if she had to lie in order to make others feel happy. She was not one of those people who were difficult to be around and at times that we misunderstood her, I now know she meant well. I know that today because I am a mother. I once heard my father yell to her from the back of the office, "Juana, stop

engaging in very long conversations with customers! They might have other things to do. You are not on a talk show!"

I was not mad at my mother because I thought that she did not love me. I knew that I was not her favorite child and as a young girl never really felt a need to be the favorite one. I thought that my father's love was enough and that he would live forever. However, the moment I saw her in the hospital a flood of emotions and memories swarmed through my mind. When I was sick she took care of me.

The way my mom was made me realize how we are all the same. Our bodies are decorated with superfluous things, but when we get sick we are all the same helpless people. There is no difference. We came into this world naked and we will leave naked. We take many things for granted, but the fact is that anything in our possession is from the Lord. We should be thankful to him. People need to forgive, as human as we are. We often get angry over things and allow such anger to become a convenient excuse being the humans that we are. However, what makes us more human is to forgive.

Sometimes people go through life with traumas from their pasts haunting them. They seemingly go around in circles, in a cycle that doesn't seem to end. Around and around they go with the same bitterness and anger. Whoever hurt them, betrayed them, whoever didn't return their love all this bitter past ruling their present. The past is good to remember, but only if taken with the idea of learning and growing from it. In other words, take something bad and make something good, which is what we need to succeed. Amish people do that and so do Buddhists, Jewish, etc. Jesus spoke about forgiveness, so what makes people blind or incapable of seeing what God wants from us?

Nobody is against us; we are our own enemy. Keeping all that baggage in our lives and in our minds impedes us from seeing what

we also do to others. Such bitter people live their lives in accordance to what others do, or for, them instead of what they can do for others. The worst part is they don't even see what they might be doing to themselves. I learned that love is somewhat related to chemistry. Sometimes you might have more chemistry with one person than another, but that doesn't mean that we ought to love only those who get along well with us. This insight also applies to our relationship with our kids, parents, and siblings.

I chose to forgive whatever my mother made me feel back when I was little girl because I may have seen her intention in a different light. Understanding is also a way to forgive, which will lead us to feel peace.

Who am I to judge? Am I a perfect mother? I would be afraid to answer that question myself. I used to think that she never cared for me since she didn't even spank me, but the truth is she was never a violent person. She was the most peaceful woman I have ever known. Above all, she was a mother. Since becoming a mother I know that although it is possible is to have more chemistry with one child, it is impossible to love one more than the other. Of course it goes without saying that the more time spent visiting with a specific family member, the more attached a person gets to him or her and our children will have their "preference" on that person.

I now know what drew me close to my mother, more than I would have ever thought. I think that she was just misunderstood and I know that feeling. Sometimes, it's difficult to show to others how you feel and by trying to explain things in a better way some things become misinterpreted and misunderstood. Ever since the same situations have happened to me, I no longer try to explain. I just simply ask myself, *"Is the comment I have going to change anything?* I leave it all in God's hands. It's not that difficult to understand others once you put yourself in their shoes.

As most are aware, military kids are often raised far from family. My kids were hungry for family affection just like all the other kids. My family loved them and their father's side of the family loved them too since they were the first grandsons. They had two grandmothers who were far away and they needed a grandmother near them.

I begged my mother to fight for her life else we wouldn't have anyone to give us advice or to tell us that nothing in life was impossible whenever we had a problem. "Give me more of your time! Give my children more time with their grandma," I pleaded, "My kids just began to have you...I just began to understand you" but he Lord took her soul the next day.

DIFFERENT CULTURES

"And one of His signs is the creation of the heavens and the earth and the diversity of your tongues and colors: most surely there are signs in this for the learned." Quran (30;22)

One of the things that I loved about being a military wife was the lessons I learned from different cultures. I especially gained new insights about raising my children, empathy, and interacting with people from various cultural backgrounds. I always felt that it was one of the requirements of God. How could some people consider themselves a good follower of Jesus if they can't even understand a person of a different race or nationality, a brother or a sister? If they don't feel that way, why should they even go to church? Are they hypocrites?

These were some of the big questions I needed an answer to out of all my childhood questions. Once I overheard Mrs. Martina telling her daughter that if she saw her playing with Carlitos, a black boy with lice in his hair, she would send her back to her father. "Maria! Don't play with that *piojoso*[4]!" Mrs. Martina would often yell. (a person who has lice). Carlitos in his defense would often tell Mrs. Martina to smell his hair, which smelled like a coconut fragrance, thus I was confused. I remembered how his grandmother used to braid his hair and thought it to be the opposite effect. I thought that lice go into clean and straight hair like Mrs. Martina's daughters, while avoiding braided hair like Carlito's, or at least that was what my grandmother used to say. "No, *mi niña*! Lice don't discriminate!" The point wasn't about lice and the hair they prefer. The point was about the views of Mrs. Martina who happened to be among "the most pious women of the church." Those things made me very unhappy and confused when I was a little girl. Unfortunately, there will always be some Mrs. Martinas everywhere.

When I began working with immigrants, I met a big family from Mexico. I had a lot of respect for them because of their family values. Some may have arrived to the United States with nothing but the clothes on their back, but they made sure to pack their family morals with them. When they are together, many live in the same house. They help each other and no one is considered better than the other. If one person already has a house, they will put their money together to buy a house for another family member and repeat the process until all family members have the same lifestyle. I learned the same thing from some Sudanese friends. My friend from Mexico once told me that if one person from the family was wealthy, they would make sure that all of them are wealthy.

[4] Piojoso is the Spanish term for a "lice infested" individual.

Perhaps what I admired most was the respect that each family member gave to one another. An uncle is everyone's uncle and if one person bought a sweater for their nephew, all of them would have sweaters. The godmother and godfather are actual family members who take care of the child they promised to guide when the child was baptized. I really admired that mind set because when I was Catholic I never fully understood that duty of being a godmother. As a matter of fact, I never considered myself to be a great godmother.

I taught my children that the type of presents that others gave them was not the most important thing. Sometimes a person is not able to afford the gifts of our liking, but if someone gives you something they must cherish the item as if it were as valuable as gold because that person thought of them. Likewise if financial strain limits us from buying someone something, then we should at least try to make ourselves available when they need kind words or advice. Those principles were the most important thing.

Being a godmother was not a duty that I loved because it was a duty that has become commercialized. What most people don't understand is that the main purpose of a godparent is to guide the godchild spiritually. Some people in our culture, teach their kids a rather different idea and if the godparent can not fulfill those materialistic obligations, then the children get disappointed.

The Catholic Church teaches that a baby is born with the original sin because of Eve's disobedience to God when she gave Adan the fruit from the forbidden three. Only the water can purify the baby and save him from going to the hell. Therefore, the child needs to get baptized and parents appoint godparents who act like sponsors. This sponsor would act as the protectors if the parents were to die, to guide them spiritually. In some cultures, however, such status has become associated with gift giving which some individuals may not be prepared to do.

Other problems I see between different cultures is the way some have a more conservative or narrow minded approach to things creating problems with communication not only found in the language barrier. For example, some people walk through life thinking that only people from their race, gender, or country are better than any other. The problem I see is that we need to understand that the world is full of people from different countries. We spend time with them at work, markets, travel, religious gatherings etc. We are like a salad bowl but some judge others according to the way we were taught in our culture; therefore, there is a lot of ignorance and misunderstanding.

Often it might be heard that a person is accusing another who is not from their country as a close-minded individual, but who of the two, the accused or the accuser, is the one acting in such way? When a conservative culture accepts another culture in their circle, they are proving that such malice and aggressions are void. Yet, most people repay such "conservative culture" by criticizing or saying, "No, they are closed minded." With such expressive opposition, who in fact is the closed minded individual?

What I have come to notice is that some of these individuals come from cultures that exhibit a high value for their religion, their history, and a deep respect to the Lord. Acts of belittlement and humiliation on other cultures may also occur due to the absence of such values in other cultures that may not have such understanding. Whenever I see a person acting in such a manner I feel pity for them because people like that can't accept anything for good. Those are the type of people who make a point to state they were right or emphasize how wrong something is. These are the people who loose out on so much. When I was in a foreign country I learned how to handle the people and the culture by asking God, "Okay, Lord. Give me strength and open my mind to allow spiritual progression to enter my life."

CHAPTER 5

HIS CHARACTER SEEMED LIKE A ROCK

My father, whom I inherited my hair color and green eyes, was a person with a strong, yet very kind personality. He helped many people economically and was a man from his town. He helped the local baseball team and if someone owed him some money from him, he would still help them. He never forgot where he came from. He started his business washing and ironing clothes in a small room with only one machine and later expanded when he was able to buy a bigger building.

When he owned the bakery he would always set aside some bread for his friend's families and would give it to them on his way home. Sometimes people would come to the bakery at the end of the day to buy bread and he would tell them that they were sold out. When the people saw that he still had some bread, they would ask, "Well, what about those?" He would tell them that they were reserved for someone else.

He was shy, but I was the apple of his eyes. If he wanted to know the truth about the latest gossip in town that involved me, he would sit at my bedside and ask, "Look, this woman told me that you're dating her son, is that true?" If I answered, "No dad, it's not." To which he would respond, "I believe you...but you need to know that the most important lesson in life is to always tell the truth because people who lie won't be happy." I felt terribly guilty every time he would say that he believed me even though I knew I was lying. He was right. I was not happy nor did I feel free until I told the truth. Later in life, I kept his words in mind and tried teaching my kids the same lesson. My father couldn't tolerate lies.

Once he asked me where I was after school, but I was afraid to tell him that I was in a place he didn't want me to go. Since everyone in town knew him, he found out where I was. He wanted to give me the opportunity to tell the truth and I lied, even though I wasn't the type of person who would lie to him. I lied to him to cover for my sister. I'm not the type of person who would divulge a secret and gave my word to my sister that I would not say anything.

After I answered him with a lie, he told me to keep walking into the back room where all the dry cleaning machines were. He then took off his belt and started hitting the machines with it. Scared I screamed but didn't know why he hit the machines instead of me. Later I learned from one of his employees that it was a matter of honor and reputation because he asked me in front of the employees who already knew where I was after a customer told him in front of everyone. He was never like that with me. At the time, I was only fourteen years old and couldn't understand what happened to him. I was angry because it was embarrassing. He was fuming mad for he did not expect me to lie to him. He always reiterated that trust was only given once, after that a lie becomes a habit.

Being a rebellious adolescent, I ran away from my home receiving refuge at my sister's apartment in New York. My father suffered a heart attack. Before I was even born, he had heart issues due to his time in the war. I guess his frustration with me made it worse. One day, I looked out the window and was shocked to see my sisters who were supposed to be in Spain standing outside. They told me that he was sick, which caused a great deal of suffering and caused me to feel extremely guilty. My father! How could my actions cause such great pain to the person that I love to the point of causing a heart attack? When I arrived home he was already back from the hospital. Nervous and not knowing what to expect, I entered the room where he was resting and suddenly heard his fragile voice. I stopped dead in my tracks by the door. He told my mother not to get mad at me or even ask where I was. He added, "She might be hungry

and needs you to be a mother to her." I never forgot that. A week later I was sent to Barcelona with my older sisters.

I always considered myself a philosopher. To me, actions speak louder than words. When my father forgave me, he who had all the right to punish me, he taught me how to forgive. He chose to pardon me when he could have chosen to send me to a home which houses adolescents who abandon their homes. He never talked to me about my past or my mistakes when I was a minor living by his rules. Instead, he only talked about the present and the opportunity to change my life by sending me to Spain.

I will never forget this lesson because to me forgiveness is a feeling that my father accidentally taught me. My father; a man who was not really a perfect human being and who's character seemed like a rock. Forgiveness is a very hard thing to give sometimes, but once we do we feel happy. Likewise, by forgiving we embrace the opportunity to start a journey fresh and generate progress. Whoever can forget that someone once hurt them becomes a happier individual. My father's lesson tuned me to a different frequency and gave me inner peace. At that moment that discovery also made me realize that it may have been what Jesus tried to teach humanity when he said "love one another."

My actions taught me that one is happy when one feels free, but freedom is subject to some conditions. The moment that we hurt others there is no freedom. When our guilt fills our consciousness or when we construct our life in another's suffering, our heart is not totally free. However, my father's lesson was even deeper. Whoever allows the past to ruin their life is only ruining their heart and the opportunity to gain other things in life.

Sometimes, we lose a day talking or thinking about the same problem that we have had instead of reading a book, learning a new hobby, or perhaps finishing the work that we have left behind. Now,

when placed in a situation that I don't like I try to find the best part of the situation because now I can say from my own experience that everything happens for a reason.

I will always repeat the same words until I, myself, can understand it. The way we approach such given experience only results in our individual success or failure. Yes, I was an adolescent who ran away. Yet, I learned that in my culture at the time that I was raised, we might have an impossible child but we fight hard to correct the issue instead of throwing them in the streets or passing them to the government like a hot potato.

What happens then when we are old? They take care of us, they take us to family events, and they give us love instead of abandoning us at a nursing home. The most important and necessary factor is to open our mind and let everything flow instead of fighting each situation or complaining. Believe me, when something happens in a way we didn't intend or desire, this could be a result of a better opportunity that will present itself along the way. The Lord knows better than us.

IS WHAT WE SEE ALWAYS THE TRUTH?

Excerpts from my diary in 1975-1981 until present day

As long as I can remember my life consisted of my friends, my family, music, and my faith in the Lord. My parents were very busy people and my father was not a religious man, so how did it occur that I was in constant search for spiritual things? I'm not sure if I learned it from my grandmother or from feeling lonely and confused when I was a child.

One of the most important values taught in Puerto Rican culture was to not lose one's virginity. One of my sisters taught me that a woman should not lose her chastity unless it is with her husband. She told me that once a boyfriend gets what he wants from his girlfriend, he would not want to marry her. He will leave and nobody will ever want to marry a person who has been with another man. I always kept those values on my mind. My mother and my sisters were Catholic and made sure that I took my first communion, but my inspiration was my grandmother. She was a Catholic who was very passionate about her faith. There were times when I tried all kinds of religion and visited various churches.

I was not acting right and was a rebellious adolescent, but even then I was looking for God. I gave my parents a hard time whenever I went to visit my friends. I would defend myself, but no one ever believed me. It's frustrating to try to explain what you really feel in your heart, while others keep saying what they think you are thinking. I wanted them to believe me because I was not doing anything wrong. I knew that my father believed me, but by then it was already too late.

Once I went back to the island from New York they sent me to Barcelona. The truth is that I was always around people they perceived as a negative influence on my life or maybe it was because of their low-income background. I certainly had a perspective on the various social statuses in society and it was especially hard to be around the "high-class" at my private school; high-class students that were neglected by their parents and caused trouble around campus. Hiding drugs inside their lockers while other girls bragged about losing their virginity. I never felt comfortable with them.

To be specific they never liked me because I wasn't part of the cool kids. Instead, many of my friends who were in a low social status were the ones who were not into doing bad things, out of respect to their parents; of course one could find flaws with both

groups. I begged my parents to change me to a public school and my sister convinced them.

To my joy when I came back from Spain I was able to help in one that was locate in San Juan, Puerto Rico. My father's views about drugs were very strong. If my parents were to be reading, they would be very happy to know that, although I loved Hippies, never did I smoke marihuana or use any drugs. I think that during the time I did not understand what a hippy was all about. To me it was only some kind of a fashion statement, which involved faded clothes, bandanas, and the peace sign.

The truth was I was just using the gift I was born with...counseling and social work. My dream. My forbidden friends, as I liked to call them, had many problems from economic to emotional and I always thought that I was capable of sorting them all out. The reality was that I was learning many things from their families and they taught me that there are four kinds of people in life.

One of which are wealthy people, but they take everything for granted. The second are the humble ones, but if you observe carefully the humble one another that hustle them, fooling them, and crushing them like a bug. The third are the people who don't have enough money, yet want to show society that they are rich when in reality they have nothing but debts. These are the kind of people that are not happy because their entire life is a lie filled with nightmares about their debts. The last kind of people are the people who live simple lives. They are the ones who make me happy because they make sense to me. They have little houses that don't have proper roofs or big bedrooms like mine, but everybody eats together in the table. There is an abundance of love and harmony. In the end, it was up to me to choose which kind of people I wanted to be associated with.

My father once told me that if I saw a person bending over to pick up a penny chances were he probably had a small house, an old car, and was probably rich. In contrast, someone who doesn't bother to pick up the penny is probably the one in need and would get embarrassed if somebody saw them picking up a penny on the floor. These are the individuals' spending money as if they are rich showing people that they have what others don't because they choose to live in a way that impresses members of society. I analyzed what he said and pondered the validity of such truth or if everything we are taught is only a product of society. What about religion then? Do we learn only what society wants us to learn? If all the books about religion teach only what they want us to learn then how can we learn the truth?

Something I've noticed in today's generation is the ease at which corruption and manipulation occur. People abusing the system by creating charities and taking the donations to pay for their personal interests. With the advancement of technology and the internet, individuals now have a greater possibility to masquerade as a wolf in sheep's clothing while climbing the ladder of society's self preservation and success. While enacting as humble individuals, these people compile ideas from other hard working creative people and use such ideas as their own in an effort to gain wealth along with fame.

The life of a military wife resembles the much of a learning institution rather than a life itself because of the varied circumstances that allow someone to learn from experiences. For example, one month you could be working in Japan at the commissary[5] and a few months later be working for a charity in Alabama. Such circumstances have provided me with some insight into some of the

[5] Commissary is the military term for a grocery store on post.

corruption that occurs and I feel like I have seen it all. Like when children taken into custody by the state are given drugs by the employees or have sexual relationships with some of the children. All this, while you turn the other cheek. A sad reality, but true as I saw these events unfold with my own eyes even if others acted blind. People prefer to live a nice life and have a mentality that if you can dream it you can achieve it, while the rest of the world is pragmatic. Whichever way you look at it, the truth is that we only have one life. How can we fix this world? How can we obtain the answer?

After deciding to obtain an answer and satisfy the urge to attend a congregation, I decided to read the bible. Slowly. Chapter by chapter. Beginning to end. I read and read everything. Even verses in which I couldn't understand. I wanted to see if I could find the answers to my questions or at least feel some sort of peace inside.

BE A CARPENTER, BUT BE SOMEBODY!

One of the most important things my father told me was that I needed to have a career and I needed to study. He saw education as a means for a woman to be independent and would often say, "If you marry someone that mistreats you, all you need to do is find a job in your field and walkout with your head high." He was a real motivator and among his inspirational phrases his favorite were: "you need to be able to grab the bull by the horns" or how "life is like a roller-coaster you must deal with the ups and downs. Six months may consist of wealth while the other six are bad." He was a man that didn't believe in divorce and when I think about it none of my brothers had a bad marriage. One of them was married and divorced at a very young age. Yet, they both treated their perspective wife with respect the way my father treated my mother.

Having an occupation is important. Do you remember that man standing at the corner traffic light asking for money? He was a veteran from Vietnam, a war hero. There are many people like him. Some veterans come back mentally unstable while others just cannot seem to find a job or was filled by more qualified candidates who have a bachelors degree. Finish school is my advice. I would and cannot advocate against joining the military because of everything I witnessed while being married to a soldier. Yes, I had some bad experiences, especially in regards to the medical care I received, but I also had the best experiences of my life. However, if the military is the path that a person chooses I would highly recommend that the individual asserts themselves an occupation outside the military. Chances are the sacrifices performed during their service will long be forgotten, no matter how many yellow ribbons are posted.

Civilian life is not filled with ranks or chain of commands. You are given the title of Mr. or Mrs. They will ask for your previous occupation, experiences, level of education, or what university you last attended. Although I must add that the military has changed in regards to their quality of corps that are sworn in. More people with a bachelor's degree have joined the military some with the idea to serve their country after September 11.

"Don't let anybody mistreat you," my father would say. My father always gave me smart advice but he was a man that lived by example. Like how his marriage was lasted until death do them apart. My mother outlived my father by ten years. After all of his life lessons and philosophy, I was never really advised on how to walk out of a dysfunctional marriage. The faithful and loyal man that he was, would often say, "Why I should have another woman if I already have what I need with the woman I have at home?"

People tend to forget that marriage is sacred. My dream was to follow my parents' example and be married forever. I was only twenty when I decided to get married. Since according to customs

my father was responsible of the expenses, he gave my mother the money to prepare for the wedding celebration. My father did not go to my wedding. "The day you leave my house, you should have a profession or at least an occupation. After that you can leave." he would say as he emphasized the golden rule of the house. I tried to reason with him by explaining that I only required six months in order to finish my bachelor's degree, but such reasoning fell on death ears.

Later on, when I had my first marital problem, I wanted to go back to my parents' house. My mother wanted to help me, but my father disagreed and said, "No, I can't do that as a father I tried to guide her to get a profession or an occupation before marriage, she did not listen. If we help her we are contributing to a divorce. Do you want your children to get a divorce?" My father asked me if my husband beat me at which I responded with a no. He told me that he could not help me because when a person decides to get married that exhibiting that they are adult enough to fix their own problems. "Go back to your husband and try to fix the problem like an adult." he said, "Marriage is a very serious matter in life. I am not going to help anyone in my family end up with a divorce." I'll never forget that powerful lesson my father taught me; it was probably the best advice given and one that I will be eternally grateful for.

Although when I learned about the way marriages are in Islam, I wasn't sure such advice applied. I believe that marriage in Islam is great because of the Protector that can help to eliminate conflicts between the couples as much as possible. The duty of "the arbiter" could help eliminate any conflict and be beneficial in regards to how the couple approaches the next situation. Such situation happened with a couple I knew whose parents' intervened in an effort to provide wise advice and a levelheaded approach. Yet, if things still remain unresolved the couple could then divorce after further attempts to come to a resolution. After all what I learned was

beneficial and clarified a misconception that I had about "arranged" Marriage in Islam.

What a relief to find out that in Islam nobody can get marriage obligate it by anyone even their parents, if the woman don't agree they must accept it and find other person that she can agree to marriage. What a great feeling to learn that the woman has a protector that can find out if the person whom she wish to get marry can be a Good husband because of his background and reputation.

CHAPTER 6

A LESSON TO CLEANSE MY SOUL

When my husband and I were married he was eighteen and I was twenty. Due to my immaturity at the time and lack of understanding, after we married I suggested to my husband that never ask our respective families for financial assistance. For that reason, pregnant with my first baby eager to have our own apartment, we moved from his parents' house to Old San Juan, the capital of Puerto Rico This was going to be our first Christmas together as a result I wanted to have a beautiful tree. I asked my husband for the tallest, biggest tree that measured six feet tall. What followed was one of the most beautiful experiences of my life that happened during Christmas and was especially witnessed by my husband.

He told me that he was not going to be able to buy that tree because he was not making enough money. He was only a nineteen-year-old college student during the 80s at that time. In order to be able to live in Old San Juan it was clear to me that we both had to work, but I was pregnant and in my last year of school. I told him that I really wanted that tree and how much it meant to me to have one when it was going to be my first Christmas married. Frustrated, I unconsciously told him, "If you don't buy the tree that I want then I will go to the streets of Old San Juan and will ask for money from every tourist that I see until I can collect enough money to buy my tree." He knew that I was not going to ask for money because I was shy. If I never asked for anything from my parents how was I going to do something like that, especially when he knew I hated begging. However, he also knew that I had an undeterred spirit and

that to me nothing was impossible. Somehow I was going to get that tree. Therefore, he left to his job a little bit worried.

By mid-day, I became nervous. I did not want to ask for money from my brother because that was asking for help from my family and I knew it would not have been fair that I ask from my family when I never wanted my husband to ask help from his family. I was a very immature adolescent who only thought of how I was going to obtain it? I needed to show him that I could do it.

Desperate to feel the Christmas spirit with the tree at my home, I started creating ornaments made from popcorn and different things around the house. Deciding to walk and find a solution before my husband arrived from work, I asked the Lord to help me along the journey. I ended up near the local port and started to watch the ships that set sail. My gaze shifted from the ships to the water when I suddenly had an overwhelming feeling. I suddenly saw everything clearly and realized why the Lord didn't help me find a solution. I felt ashamed.

Anyone with the right sense in his or her head knows what was happening to me. I was not thinking right or I was not thinking at all. Many people are too busy with their life to stop and think about what they are doing. Always putting blame on other people and never claiming responsibilities for their actions. At that moment, I took the time to self reflect.

Thank you Lord for lifting that weight off our shoulders. I just realized how selfish I have been. A proud woman who wanted to have a Christmas tree but does not even know what the true meaning of Christmas is. I must first learn about the meaning of Christmas and not the commercialized idea of it. I also need to apologize to my husband and become humble, which will be my repentance.

I felt a sensation of peace when I completely discarded my idea about the tree and felt that a weight was lifted off my shoulders.

As I walked to my apartment I felt changed like if I was a new person. I started to be thankful to God for everything that I had and especially because I was carrying in my womb a baby that would soon be with me to complete my life. I couldn't wait until my first baby arrived and even though I did not want to know if it would be a boy or a girl I stopped at a store to window shop for blue baby clothes. I always knew in my heart that my first baby would be a boy. So as I shopped, I completely forgot about the tree.

On my way back to the apartment I saw an area where people threw their trash and crossed the street with haste in order to avoid the big roaches I was afraid of in Old San Juan. As I crossed the street something shiny caught my attention. Next to the trashcan was a beautiful Christmas tree decorated with ornaments and left to be disposed of. Luckily my landlord was present and talking to a lady, which allowed me to ask further about the tree. "Do you know whose tree this is?" I asked. She then told about a couple that were fighting earlier and just threw the tree away. I wondered how anyone could throw a Christmas tree away before Christmas day and then asked her if I could have it. "Yes, you can have it." she replied, "We were just calling it the tree of solitude, but now it has company."

I took the tree, brought it to my apartment, and forgot about everything. To my husband's surprise, he arrived home with a tree standing in the middle of our home. Shocked and gazing at the tree from top to bottom, he asked, "How did you get that tree?" I told him the story and how I thought it was a lesson from God because of my behavior with the situation. I also told him I wanted to apologize for any extra stress I may have given him. Gazing at the tree he forgot about everything because the tree was beautiful. After he measured the tree we realized that it was exactly six feet.

I wanted everyone to know about this story because it taught me a great lesson and helped me reevaluate myself and understand my beliefs at the time. The experience also taught me how to self-

reflect on my actions and determine how things could have been different. Am I performing my prayers with sensibility or out of routine? Am I giving importance to things that are not that important?

Finally, the beautiful day of my first-born's birth had arrived. I tried to have him naturally but I was alone in the room and it was my first time giving birth. My doctor was famous for making mother's sleep during labor so I waited until the last moment when I decided to use anesthesia. I woke up with some discomfort and I asked the nurse, "How long is it going to take before my baby is born?" She answered, "Your baby is already here. What gender did you want your baby to be?" I said, "We wanted a boy, but if it is a girl then that is what God sent me." She smiled and brought me my baby. "Well, I think that God just made your dream come true." She then placed a big baby with a big face and lots of hair on my lap. His eyes were wide open looking at me. She told me that ever since he was born his eyes were always wide open like in that way. At that moment, I was the happiest woman in the world. Some months later, my baby accompanied me when I graduated from university with a bachelor's degree.

I ASKED AND BELIEVED

*D*espite my father's example and belief that a marriage should last forever, I left my husband and went to New York bringing along my eight-month-old son. My husband and I had a big fight and there was no one to give us the advice we needed. For a young married couple, sometimes it is good to have a mediator who can give the right kind of guidance. I felt that our marriage was about to be over and did not know what was good for us anymore. One thing I realized is that if we stayed near our families and continued to pay

attention to their comments then our marriage was going to fail. We were young and immature.

My family always called him irresponsible and childish since he was two years younger than me; it also didn't help that he had a habit of getting mad at the simplest things. His family always called me lazy and the truth was that I did not know how to cook, which made me shy to cook in front of anyone. I wanted to be far away from his family while he wanted to be near them. In reality I liked his family, but did not know how to express myself.

The truth was that had I wished they loved and accepted me because I was dying to be loved by them. I loved to be around his mother because she taught me many things that I never knew. I also liked the way that his family was so close. I admired his father because he had a good sense of humor. Yet, I felt that they were looking at me like an intruder as if I were someone who came to ruin their lives by taking their son. To make matters worse, my husband didn't help alleviate the situation. Instead, every time we were around his family we would always argue about comments made by family members or misunderstandings that would occur between us.

Eight months later, my husband came to meet me in New York and we tried to work it out the best we could. We tried to spend quality time together and even were active members of the church. We also helped the homeless population stay in shelters and volunteered at the Catholic Church. During that time I used to pray with the rosary twice a day. He started college again and joined a swimming club. My only hobby was watching Hispanic soap operas and riding my bike everywhere. I was always exercising.

Fridays was our "date night" in which we would have arranged a babysitter for the night with a lady whom we all treated like a grandmother in our building. We would meet after work and go to a restaurant where he would order the all-you-can-eat shrimp, while I

had the endless jar of Sangria and steak only to end up in the toilet after I would force myself to throw up. I always felt fat not matter how many times a day I exercised. All I could think about was to keep being skinner than I already was. I never realized that what I was doing had a name and later had to fix it with a therapist.

Saturdays were special days dedicated to our children in which we would go to the park, specifically Central Park. Sundays were considered church days followed by an evening of movies and dinner. We tried to make of our marriage the best that we could, but there were always problems due to the various perspectives of our relatives. Now that I am older, I think that the problems were partly because of ignorance. If I knew then what I learned today with Islam, then we would have been happy at that time? I learned today that all that happened was the will of God. When people see other people happy, specifically in a marriage, whether they mean to or not they can sometimes cast an evil eye. Such was our case, which resulted in a marriage full of arguments and an unpleasant life. One day we were happy and the next day was a different story.

Around that time, I become pregnant with my second child and knew before taking a test that I was pregnant. I also remember telling my husband about it beforehand. I found the ability to have such a connection to be a blessing and had such connection with all my babies when I had them. I only had three children but would have loved to have at least six children, like my mother. Six children if I would have felt that my marriage was more stable. I loved being a mother; even though babies don't come with a book of instructions Of course everyone knows that being a mother is purely an instinct that arrives naturally when the time comes. By that time I was doing my masters degree; however, I was falling asleep in the classes and was advised not to register for classes the upcoming semester.

Our second baby felt like a boy to me and it made me very happy! This baby came to give my life a different meaning. Again, I

painted the room in blue color, even though I was offered a baby shower all in pink. This time one of my sisters told me that it was going to be a girl but I knew in my heart that the baby would be a boy. However, with all the problems that I was having and affecting me, I began to suffer from depression. I was feeling lonely and far away from my family.

One day the doctor called the house and told me that the baby and I were having problems. The problem lied with my platelets and if the situation did not improve within a week they would have to force delivery, which could result in choosing between the life baby or mine. I trusted my doctor and hospital because of outstanding reputation in Manhattan, New York. After a social worker called my husband and told him that I needed help from him and my family, everybody suddenly began to look after me bringing me things to eat. On a sunny day one of my sisters came to visit me and was surprised to find me in a dark room. Drawing the curtains open she interrogated, "Why are you in the dark on a day like this? No wonder you're depressed!"

I had to go to the hospital every day of the week to review the status of my blood. On the last day the nurse took my blood and after viewing the results the doctor said, "Look, today is the last day and we don't see much improvement. We can't wait any longer." They were already making arrangements for me to be admitted to the hospital. At that point I started to cry. I looked at the rosary and decided to pray without it because I felt that I had to pray only to God. I wanted to have a special connection with him and ask only him. I went to the room and prayed like never before. While I prayed a Christian woman prayed alongside me.

After I prayed I asked the doctor to check again. Protesting and arguing that there were no more chances, I convinced them to take my blood again; this was the last chance I had. After the last test was taken, they came and told me that something had happened.

"Whoever you are praying to just made a miracle," they said. Astonished and confused, they couldn't believe that my platelets changed considerably almost to the point at which they appeared to have never had a problem. "I only prayed to God," I told them. Praise the Lord!

The second surprise arrived with my baby. Although the ultrasound showed that I was going to have a girl, I had a baby boy instead. When I held my baby boy in my hands I thanked God because I felt that it was divine intervention that caused my platelets to change at the last minute. At that point, I made a promise that I would try to guide him on the right path because of the gift of my boy that God gave me.

FAMILY VALUES

My father died a year after my son was born but was able to share a few days with my baby when I visited him in my country. I had my two boys baptized there and decided to celebrate with both families by the beach. Surprisingly, my father, who was not a person of going to celebrations, decided to join us that day. My father was already unhappy with the fact that I lived in New York so when he heard someone calling me by my husband's last name, he got upset and felt that I was being mistreated.

He asked me to go take a walk with him. I could tell he was upset by the way he was walking towards the beach. As we were walking his gaze never left sight of the sea to which I asked him if he wanted to say something. Finally he said, "Look, I might not be alive next year, but I want you to know something. Never forget that your last name is Cardona. I worked hard to raise my family and give you all that you need. If you are married that was your choice to have a

different life but in reality you don't need anything from anyone. Even with my death you will have a place to be buried because I made sure our family has a burial vault."

I took his words literally, however, it was when was older that I understood what he meant. The values instilled by your family at a young age are the building blocks that help aid in creating the individual that later interacts in society. As a human being you should never forget such values that are taught because these values are going to direct your life and also form part of your culture.

After my parents died, my siblings and I were sued for our parents' inheritance. The lawsuit mandated that we had to wait until my niece became twenty-one in order for the inheritance to be relinquished. My parents worked hard to leave us with properties and businesses, the dream of any parent. In the end we were sued, but the best inheritance we were given was our education. I began to see things in a different way and saw some people's true colors when money was involved. At that time I was not a Muslim yet. As a per usual, I consult the Bible to find the answer I was looking for.

Exodus 22:"Do not take advantage of a widow or an orphan
23 if you do and they cry out to me, I will certainly hear their cry
24 my anger will be aroused and I will kill you with the sword, your wives will become widows and your children fatherless"

The judges decided that we had to wait in order to receive our inheritance of the properties that my parents worked day and night for us to have. When we were sued we were not even emotionally ready to help ourselves because of the loss of my mother. We felt like orphaned children robbed of the people who worked day and night to leave us something when they died. The ambition was bigger

and faster than us. We were judged without giving having an opportunity to understand what was happening.

When my father become sick he was told not to work anymore which he then decided to sell one of the drycleaners along with my mother's pharmacy that she owned. By the time of my father's died he only had a bakery and another drycleaners. The bakery was a stable business but it was passed from one brother to another. Eventually the bakery landed in a very dangerous economic situation and my brother decided to make a loan to pay all the debts. Some of us in the family agreed while others did not and in an effort to collect the necessary signature, one of the brothers was offered a "settlement" to receive some machinery from one of the other businesses in exchange for his approval. He accepted. After that my brother died, my mother decided to sell the bakery but soon died in the process. As a result, with all the chaos, we were sued and the judge froze the inheritance.

Money is only a paper and sometimes what is more important are the memories attached to some things. Like a doll is cherished when by a little girl then relished when she is older, what was more important to us was to keep that place we were raised in order to be able to revisit the memories of a time when we had a reason to be proud and honored. The intention was to save our houses, which was the inheritance that my parents left for all of us. All we could think of they were orphans of our own blood who were younger than us and were the only remembrance of our brother that we loved. How can someone think that we wanted to rip them from the inheritance? What we wanted belonged to everyone and would want it to be shared.

Sometimes people complicate things, especially when they are not advised by the right people or allow the Devil to whisper in their ear thoughts of ambition. What was worse was the thought of how these kids could be raised to love us if all they were ever told was

that the kids' parent had to sue their own family in order to give them what belonged to them. Isn't that the way to create hate instead of love? I learned a long time ago that whoever sows sparingly will also reap sparingly and whoever sows generously will also reap generously.

Back at the funeral service someone called us because all of our cows were in the highway due to a fire in the land. We were aware that someone wanted the land but when the rock that holds the house together is taken, everything becomes weak and falls to anything. Therefore, we let things go and at that moment only pain was prevalent in our hearts. We may never enjoy what my father worked for because till this day a settlement hasn't been reached, but I finally understood my father' advice. No matter where I was, I knew where I came from and the values that I learned would never be forgotten.

Many people who don't come from the same education or background might have the money to have everything. However, these families fall in between the cracks of disrespect and lies because of how the parents live by example. Such families need to be given the right guidance just like the examples my parents have given me.

Other than my education, I inherited wise life lessons from my father. One of the most important life lessons he taught me was to never treat a person as if they were beneath you because when we die we can't take anything with us. However, I learned many other life lessons after his death. Such examples are when a person wants money they sue, when a person wants to fix a problem they talk, and once a person starts a war they get war back. This is the reason why I always felt that Satan dominated this world because my opinion is that ambition and money comes from Satan; however, after I learned Islam I was able to separate both of them. Only when I learned about the first crime in history with Cain and Abel was I able to learn what the true nature of human beings.

One day, when my father was alive, he was driving around the town distributing bread to his friends and I was complaining because I wanted to go home right away. He told me that he was not God's favorite but he couldn't complain about his life. "It feels good when you help someone that comes to your door without asking," he said, "because you never know if God sent an angel to see if you have compassion." Today you might be rich or healthy but tomorrow you might have cancer and die poor. My father was sixty-three then he died of a heart attack.

One of the things that directed my interest about Islam is that everything that we need to know about life is seen in the Quran and Hadiths. Laws, inheritance, and orphans rights are all an example that a Muslim marriage can easily be fixed than a non-Muslim marriage. Inheritance problems are easily fixed when you live in a country that is ruled by Islamic law or at least one that follows the Sunnah. There is not better a therapist than the prophet Muhammad [peace and blessings be upon him]. All you have to do is to read about his life. When I did, my life changed. Today, 2003, I found my answer in the Quran:

Quran 4; 10 "Verily, those who unjustly eat up the property of Orphans, they eat up their bellies, and they will be burnt in the blazing fire!"

CHAPTER 7

SEVEN YEARS OF MARRIAGE AS NON-MUSLIM

*A*fter seven years of marriage many things change. We often hear that such mile marker is usually when a couple gets divorced especially if it involves a young couple. In reality many people don't know how to deal with the normal changes that occur during that time frame. There is a big difference between twenty-one and almost thirty. Perhaps I should be specific by stating that such events usually occur in a non-Muslim marriage.

Women feel and think differently than men. Women also see life with a different purpose than men. Sometimes a woman may realize that she never enjoyed her youth because she was always busy taking care of her kids then suddenly wishes she could do the things that she missed out on in her life. On the other hand, a man gets bored since he has been trying to support a family for a long time and also misses having fun. He might blame his wife and think of how nice it would be to have other sensations. Some may even wish that their wife did different things intimately. Such thoughts may offend a wife and make her feel that her husband only wants sex or perhaps he doesn't love her anymore. She may only want to hear those three words to be said to her like an "I love you", while he only wants to do those things that he never did before. Bored, he excuses his absence with work or by gaining refuge in "computerland." The husband wants something sexier while the wife mixes romance with materialistic demands. Each one thinks differently and therefore searches for the unfamiliar in other people.

Yes, as a couple grows older together and things will be different than in the beginning when the couple first met. For example,

choosing a diamond ring. When I was twenty I remember my husband and I went to the jewelry store. I wanted a small diamond while the seller showed me a bigger diamonds and I would argue that I didn't want anything big. At such statement the dealer chuckled and replied, "You'll think differently when you turn thirty." I asked him how he knows this and he replied, "Because a woman is different at the age of thirty. She wants to carry with her what she knows she deserves but at twenty, a woman doesn't think, only dreams." he continued, "At that age, she only sees his beautiful eyes, his beautiful hair, and his smile. By thirty she begins to see what she doesn't have and starts to think, 'Should I keep his eyes, hair, and smile for seven more years? What have I gained in these past few years?' She will then look at her finger and see the small diamond ring. Then she will say, 'Is this all I have from him?' She pictures his smile, his body, his hair and realizes he is starting to lose some hair already." Oh, how I will never forgot those words from the jewelry shop!

When that time approached I decided to bring new things into our life. I remember having the feeling of having been married for twenty years with everything calm and no arguments. I talked to him trying to find a solution to our problems. I proposed finding us a hobby. He was an extrovert kind of man before I met him while I was more of an introvert. Having a family environment usually creates a sense of warmth and love, but unfortunately I took those experiences away from us with my immature behavior and as a result couldn't enjoy the beauty of those experiences for years. Sometimes my husband would work two jobs along with a part-time job in order to provide for our future; while all I ever did was think about the present. He dropped out of university even though I pleaded with him to continue with his classes. He eventually listened to me years later in life. I strongly believe what helped him acquire jobs was his responsibility and drive that were exemplified by the fact that he had started college at the age of sixteen and was already two years in college by the time we got married.

Like every young couple, we were together all the time and eventually he stopped hanging out with his friends. For a couple of years he stayed at home like I did. Can you imagine a hyper man like him who liked to do sports staying at home with nothing to do? He would watch TV with me after work and even watch the soap operas. Sometimes I would feel guilty for killing his spirit and because he gained weight. He respected my wishes because he loved me and he did not want to go alone with his friends since he would rather that I go out with him.

On my end of the employment, I had tried several jobs but ended staying at home with my children. When I realized that the life that only I created began to get boring, I started to think, "That's it? Is this what marriage is all about?" I felt that there were no feelings between us anymore. I would encourage him to go out and have fun with his friends, because I thought that him being near family would not help us much. Sometimes our family would say things that caused conflicts, tension and arguments between us. On my behalf I think his major problem was his beauty. Usually if people see a handsome man they immediately think that he has a lot of women around him. After we moved and put a continent between our families and us, I began to know who he really was; a man that you can trust.

He never went around looking for female friends and he always put me before anyone else. I was his best friend, his wife, and the most beautiful woman in the world. He made me feel that I was the only one. As a result, I believe it is important that a husband and wife spend the beginning of their marriage alone until they begin to know each other very well. The reason I suggest this is because as human beings we sometimes have a tendency to listen to other opinions, which can create friction between a couple and may end the marriage.

Ask yourself, who knows your husband or wife better than you do? If your husband is talking to a woman somewhere, you know and trust that the conversation was initiated for another reason than sleeping with her. Family and friends don't know the real feelings of your partner, but it should be you who knows the intimate secrets. How can you believe or act differently with your partner just because of something that someone said?

For example, during the time that my husband was working day and night, I felt neglected. Someone advised me to try to make him jealous and in order to keep the interest alive. Hence, I decided to go out every day and act like I was having an affair or like if I had another in my life. This was a very dangerous idea) I wrote poems and I sang songs. He finally asked me, "Why are you acting romantic today?" how immature I was! My behavior was of an adolescent, the love that he had for me started from the fact that I was different from the other women. He felt as if I was a respectful loyal woman. Therefore, I realized that I was wrong but the best thing of all was that he always believed me because he knew and trusted me.

As a Muslim today in 2003, I began to understand why things happened in my life and how when something bad comes to our mind it is coming from the devil, who loves to break up marriages, and he does it in a way that we believe anything that comes to mind. We perceive things in a way that confirm what he wants us to believe deep inside. This past and the following experience describe some of the tricks he plays to marriages.

One day I decided to surprise my husband at his swimming practice. From a distance I saw him going inside a room and decided to follow him. Suddenly I saw him take his towel off and walk around naked. Shocked, surprised, jealous, and furious, I demanded an explanation. "Why are you naked in the girl's bathroom?" I said, thinking that he was going to meet someone there. Surprised and upset to hear my voice, he turned around and said, "What are you

doing in the men's bathroom? You need to get out of here now!" Thankfully there weren't any men in the room but he tried to shield me from any possible men.

Another major problem I see is that people tend to compare previous partners, who may have hurt them, with current partners in their life. For example, let's say that your partner reminds you of that old girlfriend, the one who left a big scar, what happens next?

You will never be able to give that present partner the opportunity to be themselves. Anything that he or she does will always remind you of that other person. Therefore you are always expecting the worst, which does not happen all the time. Also if he or she does something with different intentions, you will never see the beauty in what they do. Thank God my husband never compared me with anyone. He knew who I was. I was the woman who he fell in love with. A man and woman need to hear each other's beauties and praises. We lost the love and get bored of our marriage. We stopped "loving" each other. How can a person that loves you tell you the most awful things and later say that he or she loves you, while co-workers and friends are always mentioning how special a woman or man you are? On the other hand, although it is true that co-workers become family after spending seven hours a day with you, the person you share all the best secrets you have is your partner.

When you love someone, you can't hurt him or her because the only person you would be hurting yourself. Sometimes people judge a person because of silly things. For example, if you are at an interview and the lady interviewing you doesn't like people who have a Taurus sign, which you happen to be, then unfortunately you will not get the job. Such circumstances are very unfair! Maybe the person who was declined a job because of his or her horoscope, doesn't believe in horoscopes. We need to give people the opportunity to be themselves once you live with them. Life is a long

journey that can be enjoyed together! We need to build our life with realistic things when we talk about marriages and conflicts.

I learned that there is a kind of psychology where we should ask ourselves if what we are thinking or doing makes any sense. Determining a person's behavior based on their horoscope doesn't make sense. Allow the person to be themselves first before you decide what they are. There are many people who are born on the same month and have many similar characteristics but we need to understand that what determines a personality is because of their different background or experiences in life. Only The Lord is the one who knows how your destiny is going to be. Seven years of marriage is just the beginning. Conflicts are constant. Later when the kids grow up the way they acts is when we see if there was a great love and understanding between the couple. At least this was my idea about marriage and I tried very hard.

ARE SPELLS REAL?

I kept encouraging my husband to go out and have fun with friends. After all I felt guilty that he was always in the house, but he kept telling me that he didn't want to spend his time with other people. One day one of his co-workers had asked him over to her home so that he could help her move some furniture. She was in her forties, had a great body, and nice personality. He was twenty-six at that time and begged me to tell her that he couldn't go. Disagreeing, I pushed him to go to help her for the last time. To my surprise he sat me down and said, "Look that woman is in love with me and she likes to do witchcraft. Please don't ever push me to go to that woman's house alone." I teased him and took it as a joke. He stopped talking to her and he later realized that the situation at work became very unpleasant. Those were the best three years of our marriage, besides Germany. We had a calm relationship and were not

talking much to our family or our friends. In an effort to further save our marriage we had been thinking of leaving New York through the Army.

With Islam I learned that between a man and a woman the third person is the devil, which makes sense to me. The idea makes sense to me because I have seen people who were not friends or dislike each other after spending time alone in different situations become friends and then get marry. I even remember when I was fourteen in Spain my sisters used to have a friend who become pregnant of of someone who always tell my sisters that he did not like her as a woman.[6]

One day my husband came across a childhood neighbor and friend that he used to go hunting with. I encouraged him to go with his friend, so he applied for a license and bought a rifle. Later, we joined a hunting club in which we used to go camping all the time with the families and the members.

I hated shooting, but after taking several classes and a lot of practice it became my hobby. I ended up loving it. I attended these classes secretly and one day while he was getting ready with his "hunting gear" to leave with his friend, I asked him to take me with him. Perplexed at my interest he asked me why I wanted to go. "You don't even like this hobby!" he joked. I then showed him my license, which made him so proud that he bought me a rifle. He took me to the range where we practiced shooting with a target of a human body drawn on paper. In the beginning it was very traumatic experience for me, but later thought of the target as only a piece of paper. My husband saw that I was good at shooting the most difficult targets like the heart and the head.

[6] The Prophet (Peace be with him) said: " Whenever a non-mahram man and woman meet in seclusion , Shaytan (The devil) is definitely the third one joining them." (Tirmidhi).

The next day he took all the papers, with all the holes that I made, and brought it to work. Everyone kept telling him to be cautious of me and I could tell that he was very proud of me. After we shared a new hobby together, our relationship grew. This made some females in the neighborhood jealous of me, but my husband and I kept a great communication between us that this made me trust him more. He taught me the cure for jealousy when he began to tell me everything.

When he passed the Army's test, he resigned from his job and the women from his job prepared a farewell party. I did not want to go to his party because it was New Year's Eve and we had plans to go to my family's after his work. His birthday was on New Year's Day and I had a cake for him, but he arrived home drunk. I was surprised because he was not the type of man who liked to drink. I thought that maybe the cause of his drunken state was perhaps due to his lack of experience with alcohol. He was also acting very strange. That day we had a big fight, which was something that we did not have in the past three years. Later we realized that he probably had some strange mix in his beverage that caused him to act like that.

After seven years of living in New York City, my husband joined the United States Army. At that time I was trying to finish my master's degree and already had my second baby. My second baby was three years old when his father left for training. A month after his father left he turned four and his older brother turned six. I was left alone with my two boys.

When I was finishing my last class for my master's degree, my legs became swollen and deformed. Someone told me that I should try to read about exotericism and gave me a book written by Allan Kardeck. It was a different way of seeing religion. At that point I started visiting psychic centers and thought that the woman who was in love with my husband cast a curse on me. I knew how to read the

tarot cards, but that was something I knew how to read ever since my adolescent and always tried to avoid it.

I thought that going to places like the psychic center was not wrong because I was a good person. Many people think the same way and will go to a psychic today and tomorrow a church. The desire to know what happened to me reminded me of Adam and Eve; perhaps a good reminder of who is behind all of this. Of course when you know the right religion you understand the purpose of this life. With such understanding you stop searching because you finally learned what the big secret of life is, which was something that only I discovered with Islam. Satan played with my mind ever since I was little but I did not know that until now. Our last days in New York I became sick. My legs were deformed and later my hands. My weight increased from 115 to 150 pounds.

I went to different doctors to find a solution but none of them seemed to know what my illness was. I was able to walk a little in order to go to my husband's graduation in El Paso, Texas for all the soldiers that successfully completed the course. I went but he had to pick me up from a wheel chair. He took me to different doctors but no one seemed to know what my diagnosis was.

Before I converted to Islam, I thought that I knew everything about avoiding evil but in reality I did not know anything. As a Catholic there are many things that we consider normal but we don't know the things that Satan likes. We don't know his world, what they are like, and where they live. I didn't know that he likes to play with us by giving us false hope. I remember how one day I forgot to play my favorite lotto number that I used to play every week and the day I forgot was the day the number won. Now I know that this was the way he enjoyed making human beings suffer.

When I was around 16 years old I remember how the husband of the woman who used to cut my hair won the lottery. A year later her

husband had an accident. I noticed that many people who won the lottery in my town later died or a tragedy occurred at their house. As you might know by now, all my life I was being an observer. I noticed the pattern of the lotto, however, was blind enough to play it and played the lotto every week. If I knew the things then that I know now about the lottery and Satan, I wouldn't have done it. I was feeding him fuel and did not even know it. I fed him with alcohol and with many other things that I did not know because, like many people, I did not know about his life.

Alhamdulillah, I am a Muslim now and I now know how to avoid him even though he is always looking for human beings to fail. What I learned with Islam gave me hope and makes me feel relaxed. Only the Lord can touch the life of someone and only him. Satan cannot do it. I'll never forget what I read in the Bible a long time ago. The Lord taught us many things about him but it is our duty to find the truth and change our way of life before it is too late for us. We need to ask for forgiveness and ask with sincerity, always understanding that the Lord sees our heart.

Some people complain because they think that the Lord doesn't listen to them or think that he never helped them in their life. I read something beautiful about Allah that motivated me and I always have it in my mind every day:

Allah says:
"I am as my servant thinks I am
If he makes mentions of me to himself
I make mention of him to myself
And if he makes mention of me in an assembly;
I make mention of him in an assembly better than it;
And if he draws near to me and arm's length
I draw near to him a fathom's length;
And if he comes to me walking I go to him at speed." Hadith Qudsi.

The Lord is clear with what he wants for mankind. I learned what he wanted when I tried to search for that knowledge. He wanted something else from us and gave us life. Children's a great family and instead we were not giving him the time that he deserved. He gave us many rules that we have ignored through generations and have given no submission. I guess since I wondered for many years, he decided to guide me to Islam making it easy for me to find the answers I was looking for. Proving by example that he guides whom he wishes.

III - VALUABLE RECOLLECTIONS

My two boys. Germany. 1986

CHAPTER 8

LOVE CONQUERS ALL

My husband was now training for the United State Army. Being separated for six months reminded me of many things he did, especially since he was all about detail. He never failed to remember an anniversary, birthday, holiday, or Valentine's Day. He always ensured to give me a gif. If he did not have money, he would cook and cut flowers from a nearby garden. One Mother's Day, he woke me up and made a garden for me. He never wore clothes that were better than what I would were. If he was not able to buy me a nice dress he preferred not to dress elegant and if we had a car he always ensured that I drive the best one.

I wonder how many people I knew had a special husband like that. It was then I realized why people were always talking about us. With him I learned that when someone loves you they become you. What I mean by this is that before he thinks about making himself happy, he would think about my happiness first. Therefore, I always felt that if we ever separated, it will be easy for me to feel if that other someone does love me therefore it would be harder for that other person to conquest me.

When we were finally having the best moments in our marriage we left the United States. There was only one day after three years of peace that we had a big fight. I always insisted that he go out with his friends, but he kept telling me that he had a family, which consisted of the children and I. Therefore he lost interest in having fun with other people and that always made me felt guilty.

Our first duty station was in Germany and after he left we were ready to leave New York even though it was my favorite city. I tried to compare New York City with other cities I went to and I must confess that I dropped the key of my heart in the Hudson River. I never felt the same feeling of love for any other city.

If as a child I had many questions about religion, being a military wife reopened the big empty hole that I always had. Even though I knew him as a person with a difficult personality, I felt that my husband came back home different from training. Whatever the case I can say that I had what many people would love to have...a beautiful family. I felt that we needed a real congregation, a different church, perhaps a different way of life. The last three years in New York City were the best but the next three years in Germany were even better and it was happiest time for my family.

I kept thinking of new things that could help our marriage grow knowing the fact that we married young. One of the things that I wanted to learn was how to swim. I was afraid of the ocean and his family was always in boats. I started to teach myself how to swim in order to get rid of the fear I had of water because I wanted to spend time with my children when they were in the water.

One day we all went to visit my country and we were spending time with his father on his boat when everybody decided to swim from the boat to the island; the island was not too far away. Once everyone was in the water, they suddenly realized that I was swimming as well. This was a great surprise for them and was also a way of changing things for the better in a marriage. Doing something positive instead of trying to find who was to blame. We needed to find a solution to keep the marriage alive.

Marriage is a serious thing and it is forever although it might become boring throughout the years. People only experience the passion and butterflies in the stomach during the first two years.

After that the passion lessens and all you see is that he once was a prince that becomes a boring ugly toad. Such circumstances happen all the time. People keep looking for that "perfect" love by getting a divorce and then marrying another person only to find the same thing that they had the first marriage. What is important is the chemistry that one has. I had seen couples with a strong chemistry survive. At least that was my idea during those times.

My idea of a solution was to try to conquer each other with romance each and every day. If he doesn't like your hobbies, then learn his and eventually he will try to learn your hobbies. Since I started learning a few of his hobbies, he later joined me with my walking marathons and bike rides.

We started to go to the Volksmarch activity where people go with their family. In Germany, those are like small marathons where people walk ten kilometers and receive a medal or a mug at the end; it was a good hobby and the children loved it. We were able to do this with them every Sunday after church.

We always researched for information about the next town that would have a marathon. I was always looking for alternatives that could make us both have quality time together. During this time frame we both learned to give to the other. I told myself that it was better not to look only at disappointments. He was not a man who always thought about his benefit and I must admit that some men only think about themselves. It is very sad because they never see that they have a valuable woman beside them. Selfish men like that will always try to depress a woman's self-esteem and once the woman acts the way they have created her to be, they complain! This is abuse.

I reflected over my actions and decided to be honest with myself. When I analyzed my emotions I realized that I neglected him because I was watching TV all the time and decided to do something

for the sake of our children. I did not want to look for another man to make me feel different. Why would I? To end seven years of marriage and later have the same situation thinking that the father of my kids was better? He cared for my kids, listened to my problems, and looked after my health. Who could be better than him?

TRYING TO ADJUST TO THE MILITARY LIFE

We arrived at Frankfurt airport on December 23rd 1987. My kids were eager to see their GI Joe father. I asked him to not invite people during the holidays because I was supposed to work on my thesis that year. If I started going to festivities I would probably meet a lot of people and I didn't want to be distracted. I only wanted to spend my time trying to finish my master's degree, but his social nature was very strong. When I arrived to Germany he told me the news that he had invited some soldiers for Christmas Eve, after that were some casual meetings, then BBQ's, and in the end I had met many soldiers' wives.

My children were very excited because they loved Germany. However my older son wanted me to put him in private school like the one he went to in Manhattan. I had explained to him that in Germany everyone spoke German, but there was a school that taught in English. One day when my son seemed like he was finally adjusted to the new system, he asked us to allow him to walk alone. He said that he wanted to be like the other children that walk by themselves to the bus. This was a hard decision for me to make because it was not the way we used to do in New York. In the end, we allowed him to walk alone, however, we were following close behind him.

One day we saw our son hiding. To our surprise, we saw some kids wanting to beat him up. After that incident, he kept insisting

that he be transferred to a private school. However, after my husband joined the military our life was not the same and our income was less. In the end my son had no choice but to adjust to the school. Another day, he came home very happy and said, "Mom, I finally was able to beat a kid." He was excited because he felt strong instead of being abused when he did not defend himself. I explained to him that it was not right, yet wondered if it was right that everyone else tried to beat him up.

 I began to have doubts about the drastic change we made for our family go through and was beginning to think that maybe this was not the best decision we made. I remember when my son graduated from the Montessori school where they took a picture of him saying "thank you" to the teacher when she gave him the kindergarten diploma. Now he was learning how to defend himself. I wasn't sure if this was the atmosphere that I wanted for my kids.

 I also complained all the time about not being able to study because there were always activities going on or someone needed me to baby sit their children. In addition, when I went to a different branch of the University, they did not have the courses that I wanted to take. No matter where the soldier is order to go the military wives must go with their husbands, which in some cases makes it harder for wives to finish the careers that they have started. However, today, much more consideration is given to military families and things have become easier for military wives than they were in the late 80s.

 My younger son seemed to be happier and he loved his teacher. He was also learning how to read and write some letters. However, he didn't always want to go to school. I guess he was still attached to me since he was used to being around me all the time. When I had my doctor appointments in New York City my youngest was always able to sit by my side but things were different in Germany and my son hated it.

One day we were in a doctor's appointment and my son was sitting alone in the other side of the room. I was able to see him, but he was not very happy about it.

During the visit he kept trying to push the limits of the hospital regulations. He would slowly try to put his feet and arms on the other side of a rope that separated the waiting area and clinic. Finally he was about to put to cross the line, when a nurse saw him and said, "Nope, you can't do that. Wait for your mother here. Do you see the sign? It says from this point onwards, no children allowed."

Suddenly my son was seating next to me, I asked him, "What are you doing here?" Simultaneously, I heard some people laughing in the back and I knew they were laughing at something that my son did. Confidently, my son looked at me and said, "They now allow me to sit beside you mom." Surprised at that sudden change of rule, I looked at the sign and saw that he had changed it so that the sign was referencing the waiting area instead of the clinic area. As a result, he was able to sit beside me and was the cause of all the laughter.

Living in Germany was beautiful and it had a different atmosphere; it was as if I had too much freedom compared to what I was used to in New York. I also realized that I needed to adjust to the new system as well. I was getting bored and I needed to find a solution to my boredom. I was reading the Bible every day and looked for a church. There was an English service on post but most of the time my husband had military duty and was not able to assist me with the kids at the church.

I was invited to a meeting that I couldn't avoid because it was my responsibility as a "soldier's wife" as my husband would say. The meeting was not of my nature. Everyone was speaking ill of other people and gossiping about anything. There was an issue with a gift that was supposed to be for the soldiers but someone spread rumors about the Captain's wife and sabotaged the meeting. The entire

platoon was supposed to be there but instead three or four wives came to the meeting. I felt that I was in Sodom and Gomorrah. I always think about those cities when I am in an atmosphere that I don't like. I was in one of those situations in which I didn't want to be in; situations in which everyone was pushing the other off the ladder to reach the top. Everyone started to introduce themselves and they all talked about their home decor, the grandfather clocks that they just bought, the rank of the husbands, amongst other things.

Suddenly, they asked me whose wife I was and what I thought about the meeting. I made a point to voice my opinion in an effort to try and make them not like me. "If the problem is that we need to get funds for the single soldier's gift and the Christmas party, then why are we wasting our time talking about other families' personal problems." I enquired. Taken off guard, they said, "But we don't have any way to do it because there are only four of us." Amazed, I responded, "Yeah, but only one person is enough. All we need to do is start organizing the party." The Captain's wife agreed and we began to plan the party; it was beautiful.

After a while, I began to be disappointed with many things and began to wonder if I wanted our family to be in the Army for three years. I did not have the best experience trying to get a job or do other things. In addition, I saw many unfair things happening to people of lower rank. On occasion, I felt that I was treated with the same rank that my husband was. Never in my life had I felt this way before. I was used to see any human being treated like a regular human being in New York.

One day I had a bad experience and stood up to a group. "My husband does not have a high rank but I am not here because we were trying to be 'all that you can be'." I said and continued, "My husband had a great job in New York City working in social services and I brought the Grandfather clock with us from there. I didn't

come to Germany to buy it. We are in the Army because it was his dream since he was a child." Arrogance was not one of my characteristics and felt very sad that had to act that way.

Was I changing for worse? I was definitely changing because I never cared about the way a person treated me and at that point I did not care unless they were messing with my children. I realized it was true what they say said about bad apples. If one is bad the rest gets contaminated. I didn't want to be like them so I began to distance myself far away from the groups. Some people who come from a place where they never had anything seem to easily forget where they are coming from. Immediately they think that they have lots of money or a good status in life. Such a status that authorizes them to treat others lesser than them.

One time I went to a doctor's appointment and was asked if I needed a translator. I asked, "For who?" She replied, "For you." I simply responded, "No, but maybe you need one because I can speak your language even though it is with an accent. You, however, only speak one language. I understand you but you don't understand me."

Some legal aliens that work in Government offices treat people who just came to the country as if they were trash. They forget the way they came to this country. In reality they forget that nothing in this life is forever, it is all the will of God. He is the one that decides if a person is going to be in a good status forever. Of course at the time I didn't understand how the military worked or that the Army was all about ranks. Although it was tough adjusting to the lifestyle, not everything was bad because in that meeting I am grateful that I met my best friend. Since that day we have been the best of friends during the good and bad times of our life. We even had our babies the same year, 1988.

Tired of not being able to have a different conversation that did not involve grandfather clocks or hummer figurines, I decided to offer my services as a volunteer to the Army Community Services, or ACS. I wanted to teach high school to the Hispanic women that could not finish high school because they only spoke Spanish. I wanted to help women be educated and be able to defend themselves from a husband that you never know if you are going to have forever, just like my father taught me.

At that time, the Army's slogan was "Army be all you can be". Young people from high school joined the Army, got married, and left. As a result, some of the Hispanics enlisted wives did not have a high school diploma or a GED because they left school to be with their husbands in a country that did not speak their language. All my life I tried to make a difference with women's rights. Of course if someone told me that I was going to be a Muslim years later, I would have told them that they were crazy because I could not imagine Islam as a religion for a woman. Everyone thinks that it is the religion that imposes women to have no rights; therefore, I find it important to explain about this experience that I had.

If it weren't for my new friend in Germany I would have found it difficult to "fit in." The so-called friendship was hard to define from anyone even if they spoke my language. To me being a military wife was a different kind of society; to be friends with an enlisted wife. I appeared as conceited woman maybe because of my bachelor degree. My husband wasn't high ranking, which meant that I was not high enough to be friends with an officer's wife. Neither was it usual for an enlisted wife to have an enlisted husband's wife as a friend. Therefore, things did not work out for my husband who loved to invite friends with families to the house. I wanted to teach classes but couldn't because for the wife's of the same rank of my husband I was only trying to be better than them. Therefore none of them came to the classes and they stopped talking to me. However, I felt very

happy because my only friend and I were inseparable. We were like a family and to me that was enough.

Soon after we arrived to Germany, my husband was called to Greece. I was not very happy about it because I was used to him helping me with everything but now he was always going away with his unit to other places. All we had was a Volkswagen that was given to him by a soldier that left. Secretively, a friend taught me the basics of driving standard since I was used to drive automatic. During that time my son developed asthma and I had decided not to be helpless with the driving situation because I knew that asthma is a serious illness if it's not taken care of immediately. Desperate to seek help, I asked my children to go to the car and stay quiet. After turning the car on I drove to the end of the road before the car stalled. I asked a man for assistance on the next steps to keep the car going because I needed to go to the hospital. The man looked at me puzzled and very quickly told me what to do until I reached my destination. When I reached the hospital I was not able to stop on time and ran into the wall of the hospital but at least I was able to make it on time for my son to have his asthma treatment.

The next week after the incident I received a phone call. It was my anniversary and the person that called asked for my name. He then asked if I knew my husband to which I naturally said yes. Then the person on the other end of the line suddenly said, "Congratulations! He bought you a brand new car for your anniversary. You need to pick it up." He said that it was a standard car, which made me think of how I was going to drive it? How did my husband know that I was learning to drive shift? Later, I found out that his Captain saw me driving the Volkswagen. I wanted to surprise my husband but instead he surprised me! Immediately after I received a phone call from my brother, "I'm in Germany, come and pick me up." I asked him if he knew how to drive standard and he replied with a yes. I drove the car until I picked him up and let him drive the car immediately.

Being in Germany was a great experience as a family and as a couple. Everything was happiness and learning new things was fun; however, the first year of adjustment was not easy for me. I told someone that if we were in the Army any longer, I was going to die. They simply laughed and said, "Tell me that when your husband is in the Army for ten years." He was right. After eighteen years of being a military family, it felt like a bigger family. Everyone calls you to give you a helping hand or the soldiers' wives meet to celebrate that their husbands are coming back or throw a farewell party when someone leaves.

Soon, I felt that I wanted to keep that life as an Army wife. We were both happy but we talked many times about feeling emptiness when we went to the church. We were in a stage that we wanted to visit a different church. I remember my husband once told me that wherever I went, he would follow. I remembered my childhood and I wanted to summarize my life, following the examples of my parent's marriage.

I was able to walk a little and my legs were a little less swollen but still no one knew what caused my illness. My husband took me to a doctor in Germany that put fifteen shots of hydrocortisone in my knees for the pain. Soon I was able to walk a little bit better, but my weight increased. I was afraid of never being able to have another baby, so I asked my husband if he wouldn't mind if I got pregnant. Perhaps this time I will have a baby girl. Almost immediately, we found out that I had become pregnant after one month of been in Germany.

I walked more than two miles every day during my gestational period. When the day of the delivery arrived, my husband was next to me in the room helping me breathe. Suddenly I couldn't breathe and they decided to take my husband out of the room.

From the ceiling I could see down below everything that was happening to me. I saw the area in which the security makes you walk through the metal detectors. I saw everything around me. I could tell that it was the same room but at the same time it looked different. The room looked like a security screening area at an airport. I saw myself with two angels. They were trying to get my heart. One was like a devil with wings and horns and one was an angel. I could feel the pain when they were holding my heart. Suddenly I woke up and my husband was back with me. The doctors said there were some complications but I was better now and that we needed to proceed with the delivery.

When the baby came, I felt droplets of water dripping on my face. Trying to find the source, I looked up and saw my husband crying. What I had felt was his tears falling down on my face. Afraid of what might have happened and confused, I asked, "Is it another boy?" As the tears continued to roll down his cheeks, he responded, "It's a girl." I couldn't believe it! I asked him if he was sure. Maybe what he saw was the baby's behind but he couldn't talk because of the emotion he was feeling. He was crying and said in Spanish, "Ya tienes tu nena."

Later I found out that they were massaging my heart because it had slightly stopped for a second. I guess that was the pain I felt when the angels were fighting over my heart. I wondered what it would be like if I was never involved with Tarot cards and things of the sort. I wondered if instead of an angel that looks like a devil, I would have seen only an angel. I remember that I was always confused because people who spoke about near death experiences always spoke about seeing a light. The truth is that for me it felt very real and I was traumatized for a long time thinking about how I had a devil fighting for my heart. Me, the person who I thought was always a great person. Alhamdolillah, today I am Muslim and I can say that as long as I live I can be happy because I will always have the

opportunity to try do things right for the love of Allah. Alhamdolillah! Allah gave me a baby girl.

Father, Daughter, and one of my son's. GY, 1988

IS SANTA CLAUS RICH OR POOR?

When I was in Germany one of my brothers sent me a ticket to go to New York because my family was planning to sell one of our businesses. We decided to meet at my sister's house, which was a small cozy apartment in Junkers. During this time we all shared many of our memories, especially the time when we were little kids. My sister said that it was very hard to make me go to sleep early on Christmas Eve when I was little because I was asked so many questions all the time: "Why must I go to bed early?" "Because Santa is coming tonight." she would respond. "I think that you are the one who put the gifts under the tree." I said. "How can you come up

with something like that!?" She would ask. They always thought that I was waking up when they were packing the gifts but in reality I was just analyzing. I was a thoughtful child. Is Santa Claus rich or poor?

How did I come up with this idea at that age? It was very easy. I noticed that my friends, the children of my father's employees, always asked for things yet Santa never brought them what they wanted. If I think about it, I didn't get what I wanted either. I did not get the Barbie that I always dreamed of even if my father had the money to buy it. I noticed that it all depended on who worked in the drycleaners that day. In other words, my parents never had the time to buy what I wanted because Christmas was very busy time for the business. By the time they got out of work, the stores were closed.

I had what I wanted depending on who worked in the drycleaners until late. My younger brother often was able to have what he wanted because he was younger than me. If Santa was real he was very unfair or maybe there were two Santa's, one that was sometimes poor and one that was rich. Later in my life, I heard the same question from my older son, who asked me why Santa brought things to some kids and not to others. I guess there are many people in this world that thought like me.

I must say that Christmas was my favorite season. I loved the decorations of the trees as it reminded me of my sisters making ornaments in Spain. During Three Kings, I enjoyed watching them walk with camels in a parade in Barcelona. They would throw candies to everybody even up high to the people in the balconies. My favorite Christmas as a child was the first year that I was in Spain. My sister was telling me all the time that she didn't receive any money for me. I was old enough to know that Christmas was not going to be the best that year. I was thinking for a reason to convince myself on how my parents suddenly got that poor. However, if it was true they were poor, how could they pay for us to live in Spain?

The next day my sister woke me up and said, "Go and brush your teeth." When I went to the bathroom, the bathtub was full of things that I wanted. All the books that I wanted to read and especially the gift I wanted the most...a guitar! I probably never had the best grades but I love to sing, listen to music, write and read; that was my life. Whenever I wake up in the morning, I would sing my heart out and my neighbors would open their windows to hear me sing, until would find out they were listening and immediately stop.

Halloween was another favorite occasion. If someone told me that I would be forbidden from celebrating it, I would tell him or her that it would be impossible to stop me. I wouldn't even try to learn about any religion that would stop me from celebrating them. I remember that I always had the best-decorated house made from or with any material. One time my husband came home with a soldier from his unit, since they were in the neighborhood. The soldier asked him if he had decorated our house and my husband told him that this year our economic situation was not the best.

When they arrived at the house, my husband couldn't believe it. Every single corner was decorated. Perhaps it was one of the best houses that year. My husband told the soldier, "Yup, that is my wife! She always surprises me. She will have her Halloween not matter what and she did not spend a penny." I made spiders from plastic bags and used black cloth to make witches. I created a big man with boots carrying a shovel and even made a coffin out of spray painted cardboard in order to make it real.

When I learned how Christmas originated I changed my mind about it. All this time I associated Christmas with Christ but in reality it didn't have anything to do with Christ or religion. It had something to do with Paganism. How did I find out? After I searched for the origin of Christmas, I learned that it doesn't have anything to do with the Bible, which meant that it didn't have anything to do with God. Christmas is only a custom because people don't really know exactly

when Jesus was born. Of course it is a beautiful holiday where people enjoy decorating, giving, and receiving gifts but the real benefactors are the businesses.

The worst Christmas I ever had was during the first year that my husband joined the Army. I can never forget how I had to tell my son that Santa was not real. He kept telling me that it was not true. My heart was broken but I knew that he was going to be sadder if he looked for presents Christmas day and discovered that Santa didn't bring him that computer he wanted. Even when the day came he was still in denial and kept telling me that Santa was real, only that sometimes he was poor.

CHAPTER 9

LESSONS FROM GOD

Many miracles happened in my life, even though I don't consider myself to be the best person in the world. I committed sins like any human being but I had a special way of praying to God and asking him for signs. I realized now that I was being arrogant.

Yes, many people think that God helped them because they are special. Of course maybe when someone reads this statement they might think that I am exaggerating because when someone does something great to God, he will favor him or her. Yet, it is one thing to do things right and another to think that you are God's favorite child, as if you are an angelical being. Only the prophets like Jesus, Noah, Mosses, etc., were given special miracles for them to convey the message that the Lord sent for civilization to learn.

My story began after my husband left for Korea. I was renting an apartment in my country alone with my kids. The landlord did not like the idea of bringing children to a small place. I lived in the attic and he was downstairs. One day he told me that he wanted me out of his apartment the next day. It was already nighttime when I heard him having an argument with someone about money. I told myself, he wants me out of this place tomorrow but how is he going to pay his bills?

I cried a lot because before my mother died, my husband found a big house for me, but later moved to a small apartment. The rent included a small store that was used for a cafeteria. Since all the schools and some government offices nearby depended on only two places to eat at lunchtime, I was interested in the cafeteria. I decided

to move because it was a great business opportunity. Right after the landlord told me to move out, I started to clean the apartment since it was such short notice and it would be dawn soon. I thought about going to one of the houses that my family had inherited from my parents. The only problem was that my children's school was inside the base and my parent's house was in a town far away from the military base.

I packed all my things throughout the night and put all of them in my small car without any help due to the short notice. The next day I went to the landlord to return the key of the apartment. I looked for him but instead found a gentleman that I never met at his house. Soon after meeting him I found out it was the landlord's son and he told me that his father had died of a heart attack during the night. Shocked by the news, I gave him my condolences and with sadness left the place.

I knew the widow and his daughter. The landlord used to be a priest from Spain but for some reason (I never bothered to ask) went out of the church and got married to someone from my country and had children. The town knew him very well when I went to the funeral. I felt very sorry that he was dead, but somehow I felt that he was punished because of what he did to me. I felt that God punished him because I was a very special person to God, as if I were "holy".

The reason I told this story was because I had many experiences like this one ever since I was a child. I felt like I was God's favorite. I did not know that I was being arrogant. I've seen many people think the same way. Some people think that just because something like that happens to them then they are God's "special child". Today I know that it is arrogant to feel that way. Who am I to think that I was such special creature? What have I done to deserve such privilege? Am I perfect or free of sins? How did I know what was in God's mind?

Later as I kept searching on how to be closer to God, I realized that all the experiences taught me a lesson. Instead of thinking that I was a favored creature, it taught me to reflect on how short life is and made me wonder if I was doing things right with God. Sometimes we are not even aware of what we're doing. We do not know whether we are on the right path or on the wrong one. We may be here today, but gone tomorrow, and may find ourselves paying a high price for eternal life.

MY TRAUMA ABOUT ADAM AND EVE

I learned about Adam and Eve for the first time during my first communion classes. After that lesson, it was a nightmare in class. All the boys started teasing the girls because Eve listened to the snake and Adam ate the apple. Things were harder for men. If as a kid it was already torture to hear the boys tease the girls, can you imagine if it was an adult? I thought that I can only hear that joke in my country but later when I used to work at the airport in Nashville, Tennessee I was shocked. I guess the teasing about Eve was not only from countries like mine but probably all over the world. This is because we have been learning the same lesson throughout centuries. Many people don't even know that there was a time in the history that women were killed as soon as she was born because of the born sin.

I heard the same words from a passenger at the airport who was having a conversation with another man: "Women are sinners by nature! All that happened because she is a woman." I couldn't believe that in this century some man still acted ignorant like that. Tired of the joke that caused a lot of suffering during my childhood, I decided to search the Bible for the answer. The first verse that I found was in Timothy 2: 11 in reference to a woman [the Bible]

"And they should learned by being quiet and paying attention. They should be silent and not be allowed to teach or to tell men what to do. 13 after all Adam were created before Eve 14 and the man Adam wasn't the man who was fooled. It was the woman Eve who was completely fool and sinned."

I guess the joke by itself aggravated me until I had flashbacks of when I was not able to defend myself from the boys. Only in college during my philosophy class that I finally had the courage to say, "Why does everything have to be Eve's fault? She never threatened Adam to eat the apple?!" I guess I was exaggerating but these things were very important for me to help with my search about religion that I desired and needed in my life.

If I had believed everything that I learned from the media about the way women are seen in Islam, then I probably would have never tried to learn anything about it. It was just a matter of analyzing things a little bit. Ever since creation, our roles have been defined as man and woman. Today we must create or be the perfect male or the perfect female. We start teaching our kids as soon as they are born, boys should wear blue while girls wear pink. Whenever a boy cries, he is mocked because he is crying like a girl. Boys are prodded to act like boys, but should never beat up girls.

Girls can abuse boys, but not the other way around because girls are fragile. On the other hand, girls should be taught how to clean and serve. They should act prim and proper. Ever since we have been born, society teaches us the roles assigned to a gender and label it as "normal". However when someone from other religions acts in the same manner in which we were raised, we don't recognize our actions in the mirror. We forget what we learned from society and jump to conclusions or blame other religions. The truth is that we are doing the same thing as others but have labeled it feminine and masculine.

When my son was seven years old, we traveled back to my country on the airplane. The stewardess made her announcement and mentioned that the pilot was a woman. After hearing this, my son wanted to leave the airplane and started crying so loud that the pilot had to come by our seats to comfort him.

I was embarrassed when he said: "Mom let's get out of here. A woman is going to fly this airplane! I don't want to die!" I wondered how he was only seven years old but learned something like that? Where did he get that impression about women? His father was not the kind of man that talked that way about women. My husband always cleaned the house, cooked food, and washed the dishes. If I'm tired, he would take them to a doctor's appointment or take them to school. Therefore, I was confused where my son learned this idea about women. What did he know that made him think that a woman cannot drive an airplane? Perhaps I was the one who taught him this but didn't realize it.

The story about Adam and Eve made me realize how easy it is for human beings to assimilate a concept and keep it for generations. How hard it is for people to change their views even after they find information about the theme, yet how easy is it for a bad act to create chaos and affect our economy and the way we live. It shows how terror can create a different sense of freedom without losing any sense of confidence. We begin to search for someone who can give us the faith we may lack. If in previous years we were not involved in politics, we will make it task to get more involved this time around. Yes, choosing the right president will help. After all, everyone wants to come to America because we are free and we are the best in the world. We have the best laws because we are free to buy alcohol and drink all we want as long as we don't drink and drive.

A man can only have one wife yet have one or two lovers secretly without fear of being punished. A thief can steal all he wants

and have comfort in knowing that his sentence will not be too severe or he can make bail. He can steal again and again without fear of someone cutting off his hand. Adultery is normal unless someone proves differently. Our law is the best in the world. The government cares more for the citizens to have jobs and a better economy than for its own benefit and possession of crude oil or how to avoid wars. Overall, citizens can live a happy life because they put the people in jail when there is crime or rapes. Yes, they cannot change the way they learned through generations about Eve forcing Adam to eat the apple.

As a result, they must do everything to try and change how other cultures live in which religion and law are mixed. Mixing both practices, the way it was taught millions of years ago when the prophets were sent to talk about it but people ignored them. We need to help those countries that don't allow other people to be modern and free. The women need to learn to dress better and show more skin. We need to teach those women that painting their faces like clowns is better than being oppressed. To them it is slavery to see women dressing conservatively, not realizing that rapists prefer women that wear less clothing.

In an interview with rapists, they were asked what they prefer women who cover from neck to toe or women wearing skimpy skirts or short pants. They responded, "Why should I take my time undressing a woman that is covered when it's so easy to undress a woman that is not wearing much clothes!" We need to teach those countries that Adolescents should be allowed to have sex with different partners as long they take pills instead of committing the crimes when someone ignored the law of God.

In my opinion we should respect other countries cultures allow them to have the way of life that they want. People might be able to win a war because of the devastation or hunger but we will never be able to win when we fight against the law of God. I don't

mean that the war right now is a war against God. Instead what I mean is that we have been shown a different purpose or interest about this war. The hope is to make these countries follow different customs but that is impossible because it is all about faith and way of life. We read it in the story of Moses with the Egyptians and many other experiences in the Bible. We also read about it in the last book, the Quran, we saw that when God is behind a war he is the winner.

Therefore, I believe that once another country helps get a tyrant out of power then the other country should leave. Their own people will take care the reconstruction. Take care of the problems with our economy. Take care of the people. Forget about the terrorists for they will have their punishment on judgment day. Don't risk your soldiers to go out and fight a blind fight because terrorists are like roaches, once one is killed there are always more of them that multiply. Let the countries live in peace. Face it. Those countries in the Middle East are never going to change to your "way of life". The problem is that both countries have different purposes. One might do war because it might be defending their beliefs or religion, while the other might have different intentions. There might be some young people who are impressed by what they see on the Internet, the TV, the money, and the Promised Land. There will be people where their faith is very week but in reality will never get their territories or their oil. We should show our intelligence and common sense by taking care of our own problems at home. That way we show who we really are.

Peace is all we need. Respect everyone's beliefs in order to feel peace and freedom. If our spirits were shattered with the events that occurred in September 11, if the sense of freedom was taken, give us back our freedom. Let the people take care of their own people at home. Reinforce vigilance, improve the economy, take care of our soldiers, and if you get attacked again, you will be able to defend your people with pride, but once you are strong. Lives of many soldiers are lost every day. Children and adolescents grow up

without parents, are recruited into gangs, have depression, or get into drugs. People don't have jobs. Some suffer from hunger in their homes. Politicians focus on war to take advantage of the elections. That is not the real spirit of the country that everyone and I respected.

CHAPTER 10

DIFFERENT WAY OF LIFE

*W*hen I was in Tennessee I managed to acquire a job at the airport. I knew some families that were Muslim but I never had the curiosity to know about their religion because I thought that they worshiped a different God. Yes I wanted to find a good church but I wanted to keep doing the same things, like dressing the way I dressed and eating what I liked. Just like everybody else, I thought that God was in my heart and that was enough. At that point I already gave up on the idea of looking for a way of life.

I simply decided that whatever way of life God wanted for me, was not going to stop me from doing the things that I liked because I felt that I was not doing anything wrong. My idea about a way of life was more about love, compassion, brotherhood, the concept of monotheism, or worshiping only one God. I tried to find out if there was anything that could free the woman of the dogma stated in the bible that was caused by Adam and Eve's disobedience. I felt that there was more to it. What I never imagined is that what God wanted for us was deeper that what I thought.

I used to go to church. I was a good citizen of society. I was not a thief. I was not sleeping with the neighbor's husband. I was giving money to the church. What else is there that I needed to do? Like many people, I thought that Mohamed was a God and if that was the truth I was not interested to know further. I did not want to act like the people of Moses because when they were impatient they decided to adore an image instead. When I used to read the Bible I always kept these words in my mind, "I am your God the only one, the

jealous one, you are not going to have any God but Me." I was afraid that I might do something that might get Him mad. I was perfect!

One day my co-worker invited me to meet his family and asked me if I was able to teach his sister-in-law English. I told him I couldn't help her because I didn't know English myself. They thought I was an honest woman and his sister-in-law invited me to over for dinner. I was nervous because I didn't know anything about Arabs and heard many things about them.

Yet, I accepted the invitation. If I didn't meet or visit them, then how was I going to know more about them? When I went to their house I felt a sensation of peace that I have never before felt in my life. I met my co-worker's sister who just had a baby girl and later became my friend. We spent hours talking. I was fascinated with their way of life especially the way her husband was very considerate with her. Since my apartment was far away, I stayed at their home for a little while longer.

I remembered after work we all had to go to a store that opened during the night. I was getting tired of those outings after work and asked my co-worker, "Why do we have to go out to the store every night?" He answered, "My sister-in-law was at home all day. This is the only way we can take her out of the house since we sleep during the day and work during the night."

I was surprised at that answer since I never expected that level of consideration. I asked, "But isn't it enough to take her just two days per week?" He replied, "Let's say that you are at home all day. Your husband comes home from work and he doesn't take you anywhere, how would you feel?" I answered, "But every married woman goes through that. The husband goes to work and the wife stays at home or goes to work. Women must understand that."

He simply responded, "That is why the ratings of divorce are so high because the husband goes to work and then comes home, eats, and never thinks about the woman that cooked and stayed at home all day. Everything is a routine. When the husband comes home, he doesn't even spend time with her. He goes straight to the TV and watches it all night. Doesn't even bother to ask his wife about how she feels or what was the big issue of the day. Ironically, even if she said something he probably wouldn't want to hear about it anyway."

After this statement, I felt that I was the Arab and they were the Americans. Although the situation my co-worker described wasn't the same situation I had at home. My husband always listened to me and it was always me who was watching TV.

I didn't know what to answer to my colleague so all I said was: "That's why I work!" To which he responded: "Her husband gave her a choice. He asked her what she wanted to do but she answered that she wanted to stay home. She chose not to work and if she works, she gets to keep the money for herself. In my culture the husband should pay for everything and still be considerate with his wife in the same way that she needs to be considerate with him and talk to each other all the time."

I was surprised to know that a Muslim woman could work and wondered if she could choose her own career? This was not what I knew about Muslim women. I heard that Muslim women were mistreated and submitted to a man, so then why is this man considerate to his wife? How come he always asks me if I can take care of his baby while he spends special moments with his wife alone? That's not what I heard in the news about a Muslim man.

She used to tell me that wives have many beautiful rights in Islam. "My friend," she would say, "marriage in Islam is beautiful." He used to give her money to buy clothes and would even ask me if I can take her shopping. She said that it was her husband's legal duty

to provide her with a house to live in, food to eat, and clothes to wear. She told me that she chose to stay at home because she wanted be able to take care of her baby. She always explained to me that she would later try to find work or go to school. She then explained that if she decided to work her money would then belong to her because her husband is obligated to pay for the household expenses. I was totally surprised.

I asked her, "What if he doesn't do it?" She said, "Then I would talk to my parents or the leader of the Mosque which would ruin his honor as a man. They must do it; it is our right as Muslim women." I told her: "Here if you go to court and get paid more than him, you might end up paying him." I must say that I learned about all this different way of life in the year 1999 which was two years before September 11, 2001. I read it in the *Quran 4:34* "Men are the protectors and maintainers of woman."

I also thought that Muslim women are not allowed to go to school. My friend laughed and told me that there were many female nurses and doctors. Women were allowed by the prophet Muhammad [peace and blessings be upon him] to circumcise the boys. They also take care of the wounded during a war. I was very excited about having my new friend and had many beautiful ideas in my mind.

My best friend from Germany was worried about my new interest. She gave me a book about a Muslim woman who was mistreated by her husband and also rented a movie in which a man keeps his wife and daughter locked in his country. She was just repeating what she heard and learned about via the media. Why does this Muslim family act differently?

I had many doubts because what I learned all my life was different from what I saw happening at this family's home. I was given a book of Hadith which I did not know anything about. I later

learned that Hadith is anything that the prophet [peace and blessings be upon him] said or practiced on His daily life that was memorized throughout the centuries to guide Muslims and it is what they need to follow in their life. In a *Hadith* by *Al bukhary*:

"The best among you is the man, who treats his wife and children affectionately, and humanly. As I am the best among you, follow my action."

I was also wondered if Muslims could join the army because as a military wife, I always heard complaints about discriminations with females in the Army. Many female soldiers complained because they were not allowed to do many things. What a surprise when I learned that Muslim women actually accompanied their husbands to war. I was in shock when I read about that and couldn't believe that a Muslim woman was acknowledged until that point. I began to like this religion every time I learned more about it.

Here in America, women started voting in the year 1920. Black women were supposed to vote as well but everything assimilated better during the 1960's when they finally started to vote. I heard some issues relating to women and the military. Like how some units prefer to keep women out of the war even though today they are allowed to join the Army with their husbands. Muslim women were the first women that escorted their husbands to war.

There is a lot of negative propaganda about Islam and people may say many things about it. I think that is because we don't take time to read more about it instead we tend to repeat what others said or what we see on the news. I felt terrible once I learned the truth. I especially felt embarrassed for myself. A person who went to college and who likes to read, did not know anything about Islam?

LOVE AT FIRST SIGHT

When I was reading about Islam, what made me fall in love with the prophet Muhammad [peace and blessings be upon him] was the special way that he treated women. A person gave me a CD about his life and when I heard his last sermon, tears of filled with a mix of emotions streamed down my cheek. I was driving to visit my son who was 14 hours away from where I lived. I wanted to jump, cry, and laugh. I felt all kind of emotions. My body was shaking because I never heard such beautiful things.

"O people, it is true that you have certain rights with regard to your women, but they also have rights over you. Remember that you have taken them as your wives only under Allah's trust and with His permission, if they abide by your right then to them belongs the right to be fed and clothed in Kindness. Do treat your woman well and be kind to them for they are your partners and committed helpers..."

Before I converted to Islam I used to work in a shelter for domestic violence. I heard women complain all the time; "I don't know what's wrong with him. Sometimes it seems like we are happy and make love. Then next day for the simplest thing, he gets mad and treats me like if he hates me."

When I read about domestic violence and how advice was given to a man during the times of the Prophet [peace and blessing be upon him], I was fascinated. He advised men not to hurt his wife and cohabits with her at the end of the day. I also read a book about the Prophet [peace and blessings be upon him] through his wife's eyes.

"The prophet never hit anybody although pagan Arabs used to beat their wives and servants harshly and sometimes till death. Only while fighting for Allah's cause would the prophet beat the enemy. He never abused a domestic worker physically or emotionally

and neither did he beat any of his wives," said his wife Aisha [Muslim].

My son gave me some books and two of them were talking about marriage in Islam. The book's title was "Muslim husband and wife". I read a story in the chapter "Sentiments to be Honored" about the Prophet [peace and blessings be upon him] a story with his wife Aisha. It was the first time that I heard about the story but later I read it in the book by Albukhary. I read that after the Prophet [peace and blessings be upon him] came back from a crusade he saw her dolls in a niche. He then asked his wife Aisha about it and listened with interest to a story that she made up about a horse.

With this story the author is proving that the Prophet [peace and blessings be upon him] showed importance to his wife's interest. I started to think and understand if Muslims are supposed to follow the Prophet [peace and blessings be upon him] in everything he did with his life then this was a great example. I read in the book that with the story of the horses, the Prophet Muhammad [peace and blessings be upon him] gave an example of how a man should be with his wife. This was one of the first books that I had in my hands about Islam and after that I got to read many other books. Some of the *Hadith* that captivated my attention was:

"Don't cast an eye on a stranger woman second time. If it is cast of all of a sudden, and unintentionally, only once, there is no harm. In re seeing her desire comes in, which negatives the theory of self-restraint." He also said: "I don't shake hand with a stranger woman."

Any wife will feel happy and comfortable knowing that her husband can be faithful to her until the point when he looks elsewhere when he sees an attractive woman. I mentioned this because since I worked with many Muslim men, I saw them doing it.

Now that I think about it they never looked at my eyes or gave me their hand to shake when I met them. Some will do it, but many of them will shy away. I thought in the beginning that my co-worker was impolite because I gave him my hand and he ignored it but now I understand why. I liked it when the Prophet [peace and blessing be upon him] compares the woman to the rib.

"And I command you to take care of the woman in a good manner for they are created from a rib and the must crooked (bend) portion from the rib is its upper part; if you straighten it you will break it, and if you leave it, it will remain crooked, so I command you to take care of the woman in a good manner."

I read about the Prophet [peace and blessings be upon him] in *Hadith,* by Albukhari, that he was taking a shower with his wife Aisha. His wife said, "When I used to take a shower with Prophet Muhammad [peace and blessings be upon him], he used to tell me, "keep some water for me", but I used to push his hands and say, "keep the water for me." I liked to read how the Prophet [peace and blessings be upon him] played with his wife while taking a shower. While I was a Christian I never heard anyone exposing these type of experiences in order, without feeling guilty, to help the marriage of a couple. Such actions make sense to me because it is the reality of what should happen between a husband and a wife.

I also like the way he mentioned the rights of a woman while he is correcting someone who was fasting more than usual and neglecting his wife. *Albukhary 7: 127* Narrated by Abu Juhaifa on the authority of the Prophet [peace and blessings be upon him]:

Oh Abdullah Have I not been formed that you fast all the day and stand in prayer all night?" I said, "Yes, O Allah's apostle, He said: do not do that! Observe the Fast sometimes and also leave them (the fast) at other times; stand up for the prayer at night and also sleep at night. "Your Body has a right over

you, your eyes have a right over you and your wife has a right over you"

This is totally different from what I read in the Bible about women who should obey quietly because she was reason why man sinned. What I learned in Islam was that women should obey their husbands because he is the protector, but they also have rights as a woman.

Muhammad was a married man. He loved and protected his wives, as he was a man that didn't forget any aspect in their life. He seemed to give advice for everything, which made me feel complete and realize that the religion was what I was looking for to fulfill my life. When three men criticized the way the prophet worshiped Allah and thought that if they were him they would be praying day and night, fasting throughout the year, and never marry, I love what the prophet responded with.

"Are you the same people who said so and so? By Allah, I am more submissive to Allah and more afraid of him than you; yet I fast and break my fast, I do sleep and I also marry women. So he who does not follow my tradition in religion, is not from me (not one of my followers)."

I like that in Islam the idea of intimacy between husband and wife is important. Woman must be beautifully dressed and perfumed when her husband comes home; likewise, the husband must be handsome for his wife. What is wrong is to have that intimacy before you get married. I was used to see other religions not talk about it.

What I was told by my Muslim co-workers was that because of their fear of God and their love for him, they think twice before doing something that might hurt his trust. They avoid having sexual

relations before marriage or with another woman that is not their wife, which is more important than anything. The relationship between God and Muslims is private. Muslims know that wherever they go, Allah (the Lord) will know what they do. A big sin will jeopardize the entrance to paradise, which should be the life goal of all Muslims. However, in Christianity the theme of sex is treated more like an evil desire. I found that it is easy for couples to have sex before they get married or having children out of wedlock.

Before I was a Muslim, I loved God and I looked for God all my life. However, if I did something wrong I never thought that I was going to go to hell. I didn't fear God. I was not a criminal; therefore, I did not need to worry. I thought that being a good person was enough and learned that in Islam, loving God is something more serious than we think.

I want to clarify that my intention is not to criticize any religion. As the Muslim that I am now, the first thing we learned is to respect other people's beliefs. We are not supposed to fight or have an argument with people about religion because the Lord is the one that decides to whom he places the seed in his or her heart. However, as I kept writing, I realized that my intention of not criticizing anyone is lost because if I want to take everyone to my journey, I must say what is on my mind about other religions every time I learned something new.

I consider important to say that once I converted to Islam I experienced that life is not easy for people from other religions who converted to Islam; even though some think they have the "support" of the family. New converts don't understand the religion yet, but they try to explain what they perceive is their way of live to their family, with the solely intention to live in peace. Such a simple act might be misunderstood by their family like an act of extremism.

Often than not, my family or friends have asked me to do an action that is not allowed in my religion. I am a person who wants to please God and want to avoid things that make him unhappy. When I said that I don't do it because of my religion, they may mention other Muslims doing it and they immediately say, "Why can't you go to that restaurant to sit with me while we drink just because it has a bar? We see many Muslims going. Why can't you wear tight pants or a tight shirt? There are many Muslim women doing it?"

What they cannot understand is that Islam is all about struggling to go to heaven and the relationship that you have with God is personal. It's all about who is more important to you. If I am going to wear very tight pants or show my breasts to everyone then why I am wearing a hijab? How can they understand that in this life, I am not looking to follow what another human being does? I finally understand where the happiness is. The happiness is to follow only God because the day that I die nobody will be going with me. My interest is not to try to do my best in the eyes of Allah but my interest is do the best in the eyes of Allah and to have blessings not for this life but the for ones that I need when I die and be in Paradise.

My love for Prophet Muhammad was love at first sight. I liked every aspect of his life; therefore, I liked his religion. I liked the religion that cared for me as a woman, the one that set women free, and gave her rights, such as the ability to divorce if a person is not happy with their marriage. The religion that takes care of a woman's inheritance.

With the religion I was born in, I learned from my parents that one should stay with their husbands forever even though there the wife is mistreatment because as a Catholic one should not get divorced. Later, Mormons also taught me the same. Instead this religion that the world is always talking about but doesn't seem to

know much about, is very well the one giving me that freedom and peace that I need.

> *"Retain them with kindness or release them with kindness"*
> *65:2 Then when they are about to attain their term appointed, either take them back in a good manner or part with them in a good manner."*
> *"Islam does not want Divorce to be a rapid and impulsive act therefore should be three pronouncement of Divorce."*
> *Before the third pronouncement, the husband has the right to retain his wife, provided he does so in good faith .The marriage tie can stay intact only if it is sustained by love and compassion."*

I enjoyed learning about abstention from cruelty.

> *"The third duty of man is not to use his superior position as a means of oppressing his wife. Oppression can take several forms, like leaving alone. This means depriving the wife of sex, not on grounds of health, but just to punish or torment her. The maximum time allowed by the Islamic law for such punishment is four month .Before the expiry of the four months the husband must resume sexual relations on the expiry of the time limit separation must take place"*

This sounds correct to me! If someone told me before my conversion that I would read something like that from a book of Islam, I ask the person if they were crazy! Well this sounds weird but as a person who used to work in domestic violence I heard woman complaining all the time. Complaining about how their husbands had a lover and never fulfilled their marital obligations during a complete year. Is that less weird? Many of these women were living in the same house, cooking for them, some working and paying the bills but they were sleeping in different beds during many years and are not Muslims. Isn't this abuse?

CHAPTER 11

THE LAST DROP THAT GAVE ME FREEDOM

*I*t was a beautiful sunny day in my country while I was packing up my things to leave with my husband to our new order station. I knew I was going to miss my town and this time I had decided to go back to my country for one year in order to have my certification as a teacher and get a better job. Ever since I met my husband, he always suggested that I take up teaching. I guess because his mother was a teacher and he grew up having his mother near him all the time. It seemed like a good job when you have little kids.

The only thing was that I did not want to work as a teacher in the United States, especially after reading a book of Dalila Rodriguez. She gave me a different perspective about what a teacher is, a person who makes sure that students will have a good future. If you find out later in life that one of your students became a prostitute or a thief you should ask yourself, what have I done? What did I do to help him? Of course I noticed that in this country, once a kid turns eighteen, some parents send them to work, they are adults now and they must learn how to do something with their lives, but then later when their parents are eighty years old, their "kids" send them to a nursing home.

The mentality in my country was very different. I really think that when someone is eighteen, they still need guidance. They should study at a university and forget about getting work. In my country, if you have chosen to teach, it is because you really want to be a teacher and feel it in your hear because being a teacher doesn't provide the best income like a Doctor or an Engineer. The responsibility of a teacher is big because some must act like a

psychologist, a mother, a grandmother, and everything else. The joy that a teacher may feel by helping a student is more rewarding than the monthly paycheck. This is what a real teacher should be. A person that cares not only about what they teach but also about the many problems that a student might face, like having a dysfunctional family for example. Teachers have very important roles that help mold our future and culture. You can see the teacher mingle with us at church, in the store, and if you don't go to the "open house", the teacher will visit your home. It seems that there's no way you could escape from her. When I was in the school, the students shut up as soon as the teacher stands up in front of the door. There used to be a lot of respect for them and I still there may be of course I am talking about 1980 and before.

I remember when I caught a student in the seventh grade with his book open while I was giving a test. I asked him, "Are you done? I think that I am going to visit your grandmother." He pleaded, "Please don't go Mrs. Cardona." I kept thinking that if this happened in another country, he would definitely be sent to the office and get suspended. Who knows about the problems that he may be having a home. He might try to kill himself or maybe come to school with a gun and shoot everyone. Instead of going to his grandmother, I asked him why he was so scared and why he couldn't study like the other children? Every afternoon I would stay and tutor him, after which I would later visited his home. He was a child who lived with his grandparents that were very old.

Every morning, he helps his grandfather with the cow and takes the milk to his grandmother for her coffee. He feeds the chickens and pigs before going to school. He was a good kid and happy to be with his grandparents. I kept thinking about other experiences that I have seen as a military wife in other countries. The teacher would probably call Child Protective Services and he end up in the system. May even end up using drugs or molested by one of the workers. I did not feel that he was having any kind of problems because he was

well fed and loved. The school I taught in was a private school where people sent students that nobody wanted, kind of like an alternative school. My student was able to get good grades since we worked for that grade every afternoon.

I feel nostalgic when I remember those days in which my daughter was in the same school with me attending kindergarten. One day I stepped outside for a minute from my classroom and then all the kids started to chatter excessively. When I stepped back in the room, they immediately were silent. I started to talk and was trying to reprimand the students because they were making so much noise when suddenly my daughter stepped into the room stomping her foot, "Mom, I want to go home right now!" All the students were laughing and telling me: "Wow, Missi!" [this is the way students call teachers in my country] I think that you need to reprimand your daughter."

While they were joking, my daughter disappeared, and I asked my students where she went. They all said: "Missi maybe she took the public transportation already, she might be at your house." They all were joking and I sent a student to bring her back. I always wondered how she became so shy later in her life. As a girl who was raised with two older brothers, she learned how to defend herself. It was only when she was with adults that she tended to be very shy.

Our next duty station was Georgia after we were in El Paso for two duty stations. I had a great opportunity to work there by having a paid job. When I went home, I told my kids and they couldn't believe it because they were used to seeing me as a volunteer all the time. They asked if the job would be with the Red Cross again. "Oh no! Other volunteer job!" they exclaimed. When I told them my salary the kids jumped with excitement and we went to our favorite Chinese restaurant to celebrate.

I was able to go to church on Sundays but I still felt lost. This was when my son began to go to the Mormon Church with some neighbors and eventually was baptized. Georgia was a great place in the beginning because my two boys learned to bull ride, which I hated, while my daughter used to ride horses.

Soon I began to work on Sundays and the priest stop seeing me at church. I was forced to go to a different church on Saturdays instead. This was when my daughter began to take classes for her first communion. Sometimes I wondered if not going to the church on Sundays caused my daughter to be the rejected of her first communion. She was rejected two times. Later we found out that the priest was having problems with a group from my country because that group wanted to have a Spanish mass but the priest did not want to do the mass because he claimed that there were not many people going to the mass spoken in Spanish.

They decided to report him, which made him very angry. I was not aware of that problem but it was affecting me and couldn't understand why we were being punished. The first time my daughter was rejected I thought that it was because she was very shy, but the teacher told me that she answered all the questions. She said, "I am very sorry but I was not the one who rejected her." "Then why is she not one of the students chosen to make the first communion?" I complained.

They then sent me to a higher rank where I told the Bishop that my daughter not only knew the prayers but she also knew how to say the rosary because every afternoon she accompanied me and we would pray together. When the Bishop asked my daughter, she told him everything. The Bishop said, "I don't see any reason why she cannot do the first communion." We thought that the Bishop was going to talk to the priest but he did not allow her to do it anyway.

My daughter was very shy and she was just a little girl. Can you imagine the trauma she was facing? We tried another church. The same one that I used to go to and were told that my daughter was accepted for first communion. My daughter felt very happy and couldn't wait for that special day. I remember trying to keep her motivated by buying her a first communion dress with the little money I had. She was so excited because it was a small church and I also saw the opportunity to help coordinate the Hispanic community. We were both so excited looking for different songs in Spanish to sing in the chorus that was an hour away.

She was later returned to me in front of all the kids. The priest said that she did not have good references and that she must stay one more year.

Of course he talked to the same priest. I decided to clarify whatever the problem was and told my son: "Please don't get out of the car. Nobody knows that you are now a Mormon and that could be a problem if the priest finds out." He did not listen to me and went to sit by where all the parents sat while I was at the office waiting for the priest. My son was already fourteen at that time. I saw the teacher and I told her my reason for being there. I asked her what was wrong and explained that my daughter passed all the classes. The teacher told me that my daughter was ready but she didn't know why the priest said that my daughter couldn't have her first communion. The teacher told me that she felt how very unfair it was and that other kids who was from the same country was not going to have their first communion either.

I sat by the priest's office door while the teacher went to bring him over for me. While my son sat in a different area listening to the conversation between the priest and the teacher, my son overheard the priest referencing me in a belittling way and made my son very mad. He waited until we finished and finally he stood up and said: "Listen, that Puerto Rican girl you are talking about is my sister. No

wonder I am Mormon and I am done with this church!" My son said what I feared he would say. The priest immediately said, "Oh really, so this is what your mother wants me to believe that she is going to take your sister to the church when she couldn't even teach her son?"

My son said, "Yes, my mother and my father taught me. They took me to church many times. We went to church every Sunday but you guys did the same to me. I made my first communion at the age of twelve and it was embarrassing for me but I had to obey my parents who obligated me to go. However you kept saying that I was not ready but my sister is ready and she has proven it to the Bishop. Yes, I am a Mormon now, didn't that show you something?"

At that point I was very irritated, her father and I took her to different churches and it seemed like a nightmare for her. The next church that we took her finally approved that she was going to have her communion but my daughter cried. The day of her communion, she started to get really nervous and begged her father not to take her. She said, "Dad, I don't want to go please. They are going to do the same thing to me." My husband got mad and said, "No, you must go." At that point I told him, "If she doesn't want to go then we shouldn't force her." I looked at my daughter ad said, "You know, this is the last try." She said: "Yes, mom, but I am sure they are going to say no. Your church doesn't want me there." Then she cried.

I told her that she needed to have a church. She then told me that would prefer to go to her brother's church; therefore, she too converted to Mormon. I finally can say that no matter what happened in my life, I was already done with the church. I felt that I had to look for a different faith where I could see the compassion that the prophets used to have. The experience that we had with my daughter ended with the last drop of faith in my religion.

IV - EDUCATION MADE ME DO IT

My three kids at Luquillo Beach, Puerto Rico.

CHAPTER 12

THE LAST PIECE OF THE PUZZLE

Can you ever imagine believing in one thing but it turns out to be another? It's like as if waking up to find out that the family you grew up with was really not your family but instead you were adopted and your real parents were from Germany. What I want to say is that we were taught by generations to believe in one religion. We, human beings are supposed to know what is right or wrong however what we were taught that was right most be right, anything different or what our family taught us is wrong.

I want everyone to understand the question I have. I want to take you all inside my mind to understand the reason why I have chosen to convert to Islam and what I liked about it. My religious life was always a big disappointment to me. I wanted to be in a religion where I can see people doing what the Lord ordered us to do. In a sense, I find out that I was wrong.

Islam taught me that we all have free will. I will be seeing a lot of people including Muslims doing what they are not supposed to do. Who do I need to follow? I need to follow the one that sent all the messengers to talk about his existence with laws and rules. He never gave up and is so merciful that He sent many prophets to advise us of Him as the only God that you need to adore.

He said it in every book from every religion. He sent Noah, Moses, Abraham, Jesus and others. All the messengers that he sent were given a special gift to be able to make miracles so that human beings can believe that we should only adore one God, but the humans thought that the messengers themselves were gods and

adored them instead. Even the prophets themselves tried to make them understand but nobody listened.

Once I learned that Islam is a monotheist religion, I realized that all my questions were answered. I decided to look for any information that could make me feel that the evidence was very clear. I decided to search for the word God from the dictionary. What does the word God mean? At the moment, I thought that it was a silly idea but the results talk more than I thought. God is One Being, the Person Who created the Universe, the One that never dies. How can we call 'God' to human beings who can die? How can you change people's mind when they have been learning through generations one thing and believe that they are right?

My thoughts sound irrational even if I have had deep thoughts about religion since I was a little girl. However after reading the meaning of the word God, it now made some sense to me. I then decided to look for the word prophet to see if I can have a better understanding of it. I found that it meant: "the one that was contacted by the supernatural or the divine and serve as an intermediary with humanity delivering to the people this new message."

Why do human beings tend to treat the Prophets like God if they only talk about their Creator for us to adore him and not to worship them? God gave all of them miracles to be able to preach and have others believe. Just like when Jesus came and taught them about love but nobody listened. He said:

"Nobody goes through the Father if not through me."

In other words, Jesus was a prophet. He was trying to convey his teachings based on the idea of adoring only one God. He mentioned

"the Father" as the creator of the human beings. If someone thinks that I learned all of this after I converted to Muslim, then I want to clarify I've thought about this already ever since like I usually used to do I went to the Bible to find and answer, one of the verses that impacted me was when he himself explained it in *Acts 14:15*:

> *"Men why are you doing this? We too, are only men, human like you. We are bringing you good news, telling you to turn from these worthless things to the living God, who made heaven and earth and sea and everything in them. Of course people when they read "living" think in Jesus instead of concentrate in "we too are human like you" or "The God who create heaven and earth and sea…"*

I converted to Mormon because the elders were always at my home for long time because they were visiting my younger son, who was baptized as a Mormon for a few years at that time. When they invited me to their church, I tried not to be serious and would always joke with them and say: "I might go but I want you to know I am not easy to convince and besides I really love coffee."

Since Mormons don't drink coffee, it was one of the first things that made me turn away from that religion and I admit it was a very silly reason.

One day I saw tears in my son eyes when he asked me to go with him to his church. He explained that he sees all the other children with their parents when they go to church. After seeing my son crying, I agreed to talk to the elders.

I told the elders that if they are able to answer some of my questions, then I might decide to baptize myself as a Mormon. I must confess that I thought he was not going to answer my questions. One of the questions I asked were: "Ever since I started

reading the Bible, I saw a different way of life. If we take in consideration the last words at the end of the Bible then explain to me that nothing that is written should be changed. Do Mormons live the way the Bible exhorts man to live which includes love charity, chastity and community?" He answered my question by saying that Mormons have a different way of life and gave me examples about love and community.

The second question was: "Do you guys believe in prophets? The Prophets are very important in every religion. Who are your prophets? What about the disciples, did everything end with the twelve disciples? I think that someone must have followed and showed their examples of the teachings of God."

The third Question was: "Who wrote the Bible and why is it that when you read it, it feels like as if the context is jumping from one side to the other thus making it hard to follow as if some parts were missing."

"Are Mormons like other religions where they make a citation of the Bible and show what should be learned according to what they interpret or the people themselves read the Bibles and get their own conclusions?"

After I asked the questions, I must say that I never saw people so happy that they were about to cry and to my surprise they answered all my questions. Therefore, a little nervous and ready to pay the promise I made to them I decided to be baptized as a Mormon.

However there was one question they never answered and only Islam was able to answer. Therefore that sensation of fulfillment to finish the puzzle of my life was found with Islam. Why I kept in my mind and even memorized, *John 14; 15*:

15 "If you love me, keep my commands. 16 And I will ask the Father, and he will give you another advocate to help you and be with you forever— 17 But who could be that "advocate"?

For generations human beings have chosen the only religion that is familiar to society because after the crusades, or religious wars, people began to impose their beliefs. Therefore today, Christianity is the only religion accepted by most. I don't pretend to change that fact. I just want to explain what made me decide to change my religion to Islam during a time where everybody in the world hated Muslims.

I have always been a person who defends what I believe in. I believe that when something happens is for a reason. What happen on September 11 shake the world, changed mentalities, created war, hate, problems with economy, that day mark a new era in the history, but why all that happened?

Ever since I was a little girl, if someone forbids me to talk to a person because he is bad, I will think differently. Life is full of misunderstandings because everyone has a side and everyone has a truth that no one knows. If I enter a building where everyone used drugs they will treat me like a person who is wrong because I am the only one different but they will defend their truth. Am I going to do the same thing because this is what they do? No, I must read what God says about that and what He wants from me even though the world is against me. With that, I will show my love and gratitude for Him then He will take care of me. Therefore if Allah asked me to cover my hair I am going to do it, if he asked me not to give my hand to a man unless is my husband I am not going to do it. If I am going to America and some Muslims there shake their hands I am not going to fallow what they do because I strongly believe in what

Allah says in the Quran and only because we are in 2003 today I am not going to do it different, because that will make me and unbeliever and I believe in The Quran as the word of Allah and a Guide to humanity.

Prophet Muhammad [peace be with him] was the last prophet sent by God to finish what the others had started but no had listened. He was sent to reveal the message that had always been enclosed in the Bible and the Torah; the idea of worshiping only one God. Perhaps this is the difference between Muslims and Christians. Muslims worship only one God and we follow his commands or laws without asking him why or complain.

The figure below is an example of the prophets in the form of a family tree:

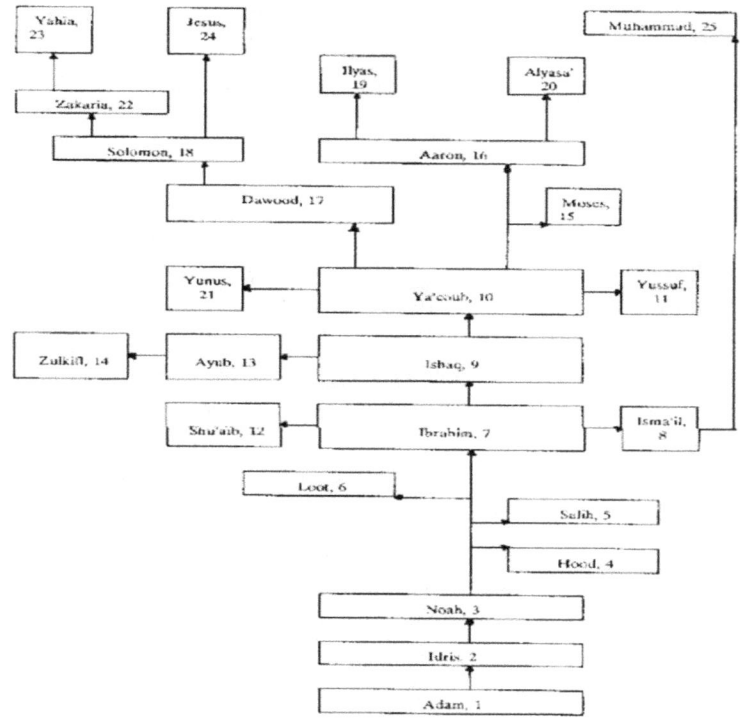

The Prophets and Books

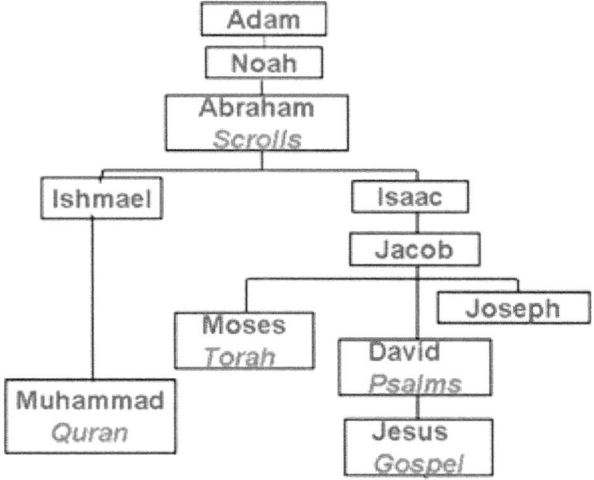

© www.Isnacanada.com/prophets 2012

WE ALL ARE THE SAME, ONE COMMUNITY

I read that in Islam everybody is equal regardless of race, color or origin at birth. Which make me fell in love more and more with this peaceful Religion. Prophet Muhammad (peace and blessings of Allah be upon him) said in his last sermon:

"All mankind is from Adam and Eve, an Arab has no superiority over a non-Arab nor a non-Arab has any superiority over an Arab; also a white has no superiority over black nor a black has any superiority over white except by piety and good action."

When I read Adam and Eve's names in the sermon I felt better because I realized that this was not what I, like many others who don't know about Islam, would call it "a strange religion". I was worried though because I didn't want to hear that man sinned because of women. However, after reading some more books, I couldn't find any evidence that suggested that women were the one who made man sin unlike in some parts of the Bible that I have come across. I found in The Quran in *Surah 4. An-Nisa 111*:

"And whoever earns a sin, he earns it only against himself. And Allah is ever all knowing, all wise. "

This means that what my friend told me about Islam, being more of a way of life in which my relationship with God is private and I am the only guilty of my own sins, is the truth." My children don't pay for my sins, lifts a heavy weight from my soul. I finally felt free. Later, I found what I was looking in *Surah 20. 115 Ta-ha*:

"And indeed we made a covenant with Adam before, but he forgot, and we found on his part no firm will power."

This was a passage I liked and I felt freedom as a woman, liberated from any dogma learned by generations. In Islam, I perceived that as a woman, I am important because of the beautiful teachings, how Islam came and liberate Eve of the Big responsibility given to her, and also the importance given to the mother. There were no more doubts; I wanted to convert to Muslim.

I think that everyone in this world can find what they are looking for but that is according to what they want to find. I never wanted to

find what others told me about without any proof. I signed my kids in the Montessori school in New York because I didn't want them to be confused like I was all my life. It would be easier for me to put them in Catholic school less expensive instead I was taking two trains to go to Manhattan. I never wanted my kids to learn any dogma taught from generations. I wanted them to have their own religion and find their own evidence. The only thing that I motivated them to have was the love for God. Ever since I was a child I've been looking for that something that made sense in my life especially for the religion that I needed. I felt even better when I read about men and women, in the *Quran; 9:71*

"The believers, men and women, are protectors, of one another; they enjoin (on the people) Al-Maruf (Islamic Monotheism and all that Islam order us to do), And forbid (people) From Al-Munkar (polytheism and disbelief of all kinds, and all that Islam has forbidden): They perform As-salat (prayers) and give the Zakat, (charity) and obey Allah and his messenger. Allah will have his mercy on them. Surely Allah is All-mighty, All-wise. The above was clear evidence to me that it is what a Muslim believes and treats men and women equally."

CHAPTER 13

THE LORD WORKS IN MYSTERIOUS WAYS

A Military wife's work is harder than some people give credit for. Being with the children alone, going to different places, and even having all kinds of emergencies. Sometimes the car breaks down, or everything in the house gets broken. The wife must find someone who can fix them or learn how to do it herself. When you are around a military community, things are easier because everyone knows that you are alone and they try to help each other but if you don't live around military families, then your life is harder. Therefore I believe that when we live far away from the military community we tend to get homesick. I guess we have what I call the "Brat syndrome". At that time, I couldn't understand why. It wasn't until my children were 20 years old that I understood. My son was always trying to pick up work inside the base or my daughter tried to find a base the first thing after arriving in London.

They felt lost if they were far away from the military and if they were near a military base they felt secure. Considering what I just mentioned about the attachment that we all felt, I must admit that I placed my children in a hard situation when I made the wrong decision of moving from a great house near the base to a smaller house, it was easy to expect that we will be asked to move out soon because the owner of that smaller house was not expecting a mother with three children. I did not have any other option but to live far away from my kids "protection." I moved to one of the family houses that was empty but far away from the base.

Being far away was an experience of learning because we felt the attachment more than ever. I also learned that is difficult for a

military wife to be alone in a civilian neighborhood. That experience was very important because I felt that the people in that neighborhood were insensible which one more time showed me how right I was in thinking how some people don't practice what they learn from the Bible.

I had a bad experience that could have ended in a tragedy but thanks to The Lord it was only a lesson. Curiously it happened in a neighborhood in which all my neighbors were in different creeds but all worship the same God. I was able to sign my kids to a school at another base however there was no transportation available. Every afternoon the bus leaved my children at a bus station. I pick up my kids two towns away from where I lived. During that day, after I picked up the younger ones, I felt something was wrong with my brakes. I took it to the mechanic to find out what was wrong. To my surprise he told me that my breaks where not working.

I started to ask everyone I saw, who could help me pick up my older son. I was worried as I felt that time were running, because it was already five in the afternoon. I went around my neighborhood, the one that lived at our right were from different beliefs from the other to our left. In front of us, the house was empty. My hope began to rise when in the right hand of neighbors I saw a taxi parked near the entrance…yeah…of course! I will ask that neighbor, how can I forget that his church pick him up every Sunday. I offered him 200 dollars if he could help me pick up my son. I explained him the situation, to my surprise; he said that once he gets home, he doesn't like to go out anymore. I cried because it was already six in the evening and getting dark. My son was already in the bus station waiting.

I was about to faint when a neighbor who owned a drug stand offered me a ride. It seemed that he was more human than my other neighbors who were supposed to follow the commandment "love your neighbors". I was starting to get very nervous because my son

sent messages that he was going to start walking. He kept asking me where I was and that he was alone in the dark and scared. He didn't know what was happening. Afraid to get help from the drug dealer neighbor, I decided to run to my van. I left my daughter and son with a friend of mine who didn't have a car. My younger son went to the police station to try to get help but they said that they were not taxis.

I did not know what else to do. I prayed, I cried and begged to my neighbors. Worried for my son I decided to leave despite the problem with my brakes but I knew that the mechanic had put some brake fluid earlier. He said that I will make it to the town that I had to go, but I needed to be careful and I have to use the hand brakes.

Scared for my son who was in a town where criminality was very high, I started the van. My two children were screaming and hitting the windows, while I was moving the van, they said: "Please, mum, don't go! Please we don't want you to die." I yell them to go back to my friend and don't go near the van and that I will be back soon.

My younger son was crying and followed me on his bike. Knowing that if I disappeared from his view, he will go back to stay with his sister. I accelerated the gas and had a goal to reach the highway. I was hoping not bump into any cars when it started to rain. My older son, who was fourteen, was no longer sending me messages. I started to cry and pray that I find him. When I was about to approach the highway I noticed a car coming. After my hopeless efforts of working the hand brakes I decided to hit a stop sign. I thought that it will give me enough time to turn into the highway. I needed the car that was coming to leave, so that I would be able to get into the highway. Instead the stop sign got broken and the van kept going down and I passed the highway. I tried to get control of the van and luckily I was able to do it.

My hope was to get to a road that might make the van decrease the velocity. On the way, there were kids playing with skateboard in the middle of the road and my only option was to fall into the river. I saw the fence that divided the road from the river and the directed the can to go straight there. As I hit the fence, I felt the van falling and I thought of my son who was somewhere and that if something happens to me, who will pick him up?

I put my hands on the wheel and saw my rosary that I used to pray every day. When I saw blood in the rosary, face and clothes I suddenly started praying.

Oh God, please don't let the van rollover and make it stop before I reach the river. To my surprise the van stopped. I touched my head and felt blood. I saw a light on my face and it was a man asking me if I was alright. All I said was: "Please get my son" and that was all I could remember. He told me he already asked for help and asked if my son was hurt. I told him no but I needed to pick him up. I told him where my son was supposed to be. He said he will send the police and I made him promise me that he will make sure that my son will be safe at my home. He then asked me if I knew the drug dealer. Apparently, this man was sent by my drug dealer neighbor to follow me, in case I needed help. After that I felt in peace and knew that he was going to try to pick up my son.

I woke up in the hospital and I started to ask for my children. I asked if my older son was already at home. The police said that they went there and did not see my son. I started to pull out all the needles stuck on my body but they injected me with something to make me calm and I fall asleep again.

Later my friend brought my younger son to visit me. He told me not to worry because someone gave his brother a ride home. I admired my neighbors because I thought that they were religious people since I used to look through the window and see them picked

up to go to church. Many times I told myself, "I wish I can find my congregation and my peace like them."

I was staying in one of the houses that we inherited from my parents therefore they knew perfectly who I was. I was not a stranger because there not one person did not know who my parents were in that town. I wondered why none of them wanted to helped me.

Some of my neighbors came to my house to apologize. I told them that this was an experience for all of us that I truly learned from. Of course I am not God, but I told the taxi driver: "You know I am a sinner. I haven't found the religion and guidance from God that you already have, but I wonder what you would do if when you die you going to hell instead of heaven. Worse, you see that the drug dealer neighbor we have is going to heaven instead. Would you ask the Lord why him and not you? if during your lifetime you went to church every Sunday and gave him 10 percent of what you have. He might ask: " Do you to remember the day that a woman asked you for a ride to pick up her son? That lady was me in disguise. I used her to see your reaction as I was testing all of you."

After all this experience, I didn't want to find any church to go to pray because I felt that the most important thing was my faith in the Lord. That is how I learned that not only going to church made you know the Lord.

I think that the Lord tested me also because the drug dealer neighbor offered me help but I judge him for what other people told me about him. Later, I met his mother and realized that they were both very special people. If you were in my place, would you take the drug dealer's offer for help? Why is it that people can pray and go to church but forget to do charity? Therefore when I read that Prophet Muhammad said: "Your smile for your brother is charity." I felt very happy. I think that the Lord was preparing me for the religion that was going to make me happy for the rest of my life.

There are many beliefs that do things one way or the other but I understand now why Islam came because human beings needed to follow what the Prophets taught us in each of the sacred books but they did not listened to them. Another one of my questions were answered. We should follow what the Prophets taught us. Christians are supposed to follow what Jesus taught them while Muslims should follow what Prophet Muhammad taught them. The truth is obvious; God wants the human beings to follow His commandments, rules and way of life. I understand why God sent messengers to do miracles. He was so merciful that He wanted to give the opportunity for people to believe in the Prophets to be able for us to do in His name. I remember reading this passage in the Bible, *Jeremiah 11:7*

"From the time I brought your forefathers up from Egypt until today, I warned them again and again, saying, "Obey me."

It's very clear to me what He was saying. My questions I have been asking all my life fit perfectly with Islam. We can read the Bible from the beginning to the end and it just repeats the same things. I don't have any guilty feeling the way I used to feel all my life because I never believed in the trinity. I felt really bad about not seeing Jesus like God. In the Bible, in *Deuteronomy 7:12*

"If you pay attention to this laws and are careful to follow them, then the lord your God will keep his covenant of love with you as he swore to your forefathers."

What kept me in doubt all my life was the first commandment. "Thou shalt have no other Gods before me." Do you understand now why I had many doubts in my life? I read the Bible from the beginning to the end, page by page. I never see people do what God wanted them to do. He keep explaining what he wanted from us in the Bible, he let us know many times that he wanted to be worship

alone, he destroyed Sodom and Gomorrah, but today the humanity is experiencing the same condition why the human being cannot see what is obvious? Therefore I kept looking and searching for the right religion to find that he wanted us to submit to him promising us Good if we do it.

"Exodus 15: 26 And said, if you will diligently listen to the voice of the Lord your God, and will do that which is right in his sight, and will give ear to his commandments, and keep all this statues, I will put none of these diseases on you. Which I have brought on the Egyptians: for I am the Lord that heals you.

Is easy to understand, the last prophet taught to worship one God. This prophet doesn't want to be seen as God. He completed the religion in every aspect in life. After I found all the evidence that I have and done comparing, I realized that Islam is the religion that I want, the one that I believe in, the one that completely answered all my questions and the one that feeds my faith and makes sense to me. The one that were wipe from earth after the Romanic Church imposed their Religion through all the fights and the crusades.

RACISM OR IGNORANCE?

The Muslim family that I met was very special to me. I was surprised when I learned that two of them were engineers. The first time that I spent the night at their house was because they invited me to eat after work. Our shift ended at 11:00 pm. It was not good for a woman to be driving alone, therefore if I stayed for dinner or I guess I must say breakfast, I would spend the night. They knew that I worked at the airport until the last flight came in because one of them was my co-worker. This was not the first time that they invited

me, soon I went often until they make me feel like a member of the family, it was different culture, different friends and I felt like if I was Cinderella. One of those night that I went to their home they told me that I had to put my shoes at the entrance. It was embarrassing for me to take my shoes off. I saw them do that but I thought it was because they were the owners so I ignored what they were doing.

 One night I observed that the husband of my friend said something in Arabic as he looked at my shoes. My face become red and I felt embarrassed because I knew what they were going to ask. A second later the question came: "Cardona, why are your shoes on? I told you to leave them at the door! Don't you know that we pray on this floor? How will I put my face on the floor when you are walking and leaving all the dirty stuff in the carpet?" My face from being red suddenly lost its color. I apologized and told them that I didn't know that the reason for removing their shoes was because that was where they prayed. They told me not to worry about it and made a joke out of it however I was having a big issue about removing my shoes. They were wet the day before and I was afraid that they might stink. How am I going to remove my shoes?

 I was unable to buy myself another pair of shoes because I was only making 5:15 an hour as a screener at the airport and all I had were those shoes. On a different note, something good brought about that terrible day of September 11 incident was that since there are no more immigrants working at the airport they realized how important the screener job is and triplicated the salary. I was not able to buy myself new shoes because I needed to pay my rent as I was trying to separate from my husband therefore I was trying to be on my own.

 My best friend helped me and bought me new shoes. I couldn't wait for the next day to go visit my new friends because I wanted to prove them that I knew how to be polite especially that I was considerate. Finally the moment came and I was able to take my

shoes off but I guess my co-worker felt that they were not handling the situation right and to them treating a guest with honor is very important because it is part of their way of life. Therefore my co-worker said: "Oh no, you don't have to do it anymore. We changed the area where we pray now. That way you will feel comfortable."

This was a great example of how different cultures handle things. While we live in a world where we only worry about our own problems, I was able to see a different way of life. My other experience with them is what I considered a normal behavior between people that don't trust others or live in ignorance. Every time I arrived at their house, they would ask me to make myself comfortable. Then would give me a towel and ask me if I wanted to take a shower before we eat. My face would blush but my friend would console me "Look Cardona I am also a woman and I know that it is very important for us to feel clean. You were working twelve hours today so I know that you must feel uncomfortable. You can take a shower, don't worry we will wait."

She was trying to be a good hostess but I was thinking about all the things that people used to say about Arabs. I thought that since they are Arab engineers, they probably have a hidden camera in the bathroom. I imagined that they would record me and then sell it at their country. It was a disturbing thought.

During the first two days of my visit, holding a towel to cover myself, I kept looking at something that might have the resemblance of a camera inside the bathroom. During a week where they were kind enough to have me as a guest, I washed myself with a plastic cup at the bathroom of the airport. I have always thought of myself as person who liked people and against racism. I considered myself as a humble human being and a follower of the Bible. However, here I was being ignorant and being the racist that I disliked. I was following other ignorant people.

People often like to talk about people from the Middle East, India or Africa, but what they actually observe is wrong. If we just read a little bit more about them, then we can learn that these families treat their guests with such special care that it is so hard to imagine the worse things said. We love to judge other people but never think about what we do. Sometimes we think that we are perfect and the others are not. We talk about discrimination of others toward us but what about the one we do to others?

The truth is that discrimination and racism is tied to ignorance. Many people that come and live in this country have more than a Bachelor's degree. Most of them speak many languages because they are very smart however they might be working as a janitor and know many things that others may not. I think that we should ask ourselves, how many languages can I speak? Do you think that you can learn another language and remember it even if you don't practice? An American who worked as a contractor in the middle east told me one day: "Do you know that some of the young people here are crazy and want to live in the States even if their houses here are palaces built on concretes."

I feel rich even if I am not from this country because I have a better quality of life. I don't worry about having a car jack or somebody disrespecting. I can order a fast food restaurant meal by internet. We eat seafood that is not expensive but best of all is that the gas price is excellent. Life is easy here.

Yes we know that some countries that have rich natural resources can use those resources to help their own people but most are under the hands of dictators who use the money for themselves however this happens in any country. What Allah says in the Quran is what they should follow. When a dictator takes over a country, it is normal to see people wanting to leave but that doesn't mean that the one that leaves are illiterate. It is sad to think that if a woman is wearing a *hijab* they are perceived as not smart or submitted by a

man. There are many women who are nurses, doctors, engineers who wear the hijab. Others that don't wear them probably work with you and yet you don't know that they are a Muslim.

However, I am not trying to say that Muslims are perfect because only God is. Islam is perfect but the human beings are not. As a Muslim that I am today, I know that the ones Muslims that committed crimes they will have to deal with the Lord the Day of Judgment.

CHAPTER 14

THIS MAKES SENSE TO ME!

I noticed that you could find answers for everything in the Quran because themes of today were indicated at that time such as politics, funerals, laws, science and more. In the book of divorce in chapter 26 of Al Bukhari (or book # 92 Hadith 417), there's a story about a man who went to the Prophet (peace and blessings be upon him) and wanted advice about paternity since his baby was born black. The Prophet [peace and blessings be upon him] asked him if he had camels and what color were they and the man answered that he had red camels. The Prophet [peace and blessings be upon him] asked him if there was a grey one among them and he said, yes. The Prophet [peace and blessing be upon him] asked the man why the camels had one grey if they were all red. The man answered maybe it was because of heredity. Therefore the Prophet [peace and blessing be upon him] said maybe your latest son has this color because of heredity.

When I read about this story, I thought how this problem was fixed with common sense. Can you imagine how great the faith of these people that believe in him? Without any doubt and respect, this paternity case was fixed and the Prophet [peace and blessing be upon him] did not approve that the baby was not from this man's own blood. Of course today if we don't have DNA, we will be lost but this issue was solved by an illiterate man.

What I never thought that I was going to learn in Islam is that women were equal to men. I thought that women in Islam were not even considered by men. Like many people, to me Islam was a religion in which only men had privileges. However, it was totally

different of what I thought. In reality I learned that women are different than men by a degree lower but is because of different reasons.

After my friend explained to me why, I then understood and as a matter of fact felt privileged as a woman. It is nice to know that the man is the provider while the woman gives birth. Of course at that time I was only looking for a reason to prove myself right because I thought that they were against woman. However I found it beautiful the way it was explained to me because it was not for the man to use his superior position toward the woman but it was only to protect her. It is beautiful to be pregnant and be taken care off instead of going to work. It is beautiful to be able to just stay at home when we have the famous "PMS" cramps or even when menopause comes. The man does not have these problems therefore it is easier for him to protect the woman. I have always loved to be protected.

I asked my friend if that was the reason why women sat behind men in the mosque. My friend laughed but did not respond instead she asked me a question: "How will you feel if you sat in the front then have to bend to pray and a man is behind you?"

I then understood what she meant. Of course it would be uncomfortable to have a man behind a woman and witness her bending while bending. For me, this was another question answered. Can you ever imagine that in Islam women can actually send her father or brother to propose her to a man? Can you believe that? Yes, it is nice when a man proposes to a woman but if you analyze that it is because we learned through society that it looks better if it was the man who proposes.

If you have read the story of Kadijah, wife of Prophet Muhammad [peace and blessings be upon him], it was told that she was the one that proposed to him. Kadijah said "I love thee for thy trustworthiness and for the beauty of thy character and the truth of

thy speech." Then she offered herself in marriage to him of course this happened through an intermediary was not her alone, the way should be. I read another story related to this theme:

A woman came to the Messenger of God and offered herself to him in marriage. When she had stood for a long time without receiving an answer a man got up and said: "Messenger of God! Marry her to me if you have no need of her." He asked the man if he had anything to give her as a dower (marriage gift) and when he replied that he had nothing but the lower garment he was wearing, the Prophet (peace and blessings be upon him) said: "Look for something even though it is an iron ring." When the man had searched and returned with nothing, the God's Messenger asked him whether he knew anything of the Qur'an. When the man replied that he knew Surah so and so and Surah so and so, the God's Messenger said: "You may go. I give her to you in marriage so you can teach her some of the Qur'an" (Bukhari and Muslim)."

This verse is not only showing me that a woman can offer herself in marriage without been taken as an "easy woman", instead, it shows me the respect and the serious a female were taken in Islam until the point the man must give her a gift when they get marry. The man also has the responsibility to teach her the Religion. In reality people don't know anything about Islam, they judge for what they hear that happened somewhere, we need to understand that what happens in any country doesn't have to be necessarily Islam because this countries might be influence by customs or a ruler, not by the Quran and the Sunnah. Every time I was learning I realized how wrong I was, all my judgments were wrong.

One time I was buying some clothes at the female underclothing section because I was looking for something very special for the wife of my son. I took one of those new things that cover only the necessary and I heard a voice say in my language: "Oh my god, look at her. Can you wear thongs too?" I looked at her and told her: "Me?

Oh no, I can't wear them because my body is not in good shape, but I can assure you that if my body was fit I will definitely wear it." She apologized but was surprised not only because I spoke in the same language but also because she couldn't ever imagine that a Muslim woman can wear any clothes under her *abayas*. People think that a Muslim woman at home looks the same way when they go shopping or when they are in public.

Sometimes when we see people who are different from us or are from a different country, we tend to judge them. We hear words like: Arabs only care for their money or be careful because Arabs do this or are like that but some Arabs are not even a Muslim.

I remember that I saw some Muslims working at the airport during Christmas or Thanksgiving. Many of them have two different jobs. I remember that my co-worker had three kids and a wife living in his country but he also had to pay for his apartment here in the United States. Some of them have a big family where their mother, father, sisters and brothers might depend of them to send money. I think it is unfair to judge the way they act because we don't know anything about their lives and why they work during Christmas since it is not their holiday.

I remember a co-worker who always brought pictures of his daughters but never about his wife. He was a nice person but we were all curious why. We thought that maybe it was because of his religion. One day I asked him: "I see many pictures of your daughters but I never see any picture of your wife." I asked him if he was too jealous to show her off or that she is ugly. I was trying to make a joke out of the conversation because I promised to my co-workers that I will find out his reason.

I thought that because we were co-workers, I had the authorization to say something like that but he was such a humble person that he didn't tell me that it was none of my business. Instead

he responded that he is the only one who can see his wife because she is beautiful and every time he goes to work he puts her in a closet and he take the key with him. Of course I knew he was joking or maybe being sarcastic. He then said that he was joking but it was incredible to believe how ignorant some of my co-workers were because they actually believed he had said the truth. After all these experiences, is it hard to believe why I now wanted to know the reality about Islam?

I noticed that some of my friends dress better at their home than when they go to work. They don't like to wear perfume or wear a nice dress when they go to work. I told my friend that at home I am very comfortable with no makeup on but once I go to work I must be beautiful. One of my friends asked me: "Why just be beautiful at work? Don't you think it is better to look nice for your husband too?" I said: "Of course but not wearing high heels. She said: "Yes, you should for him. My husband loves me in high heels and loves to see me with makeup with red lipstick. Believe me when he comes home he also wears a nice perfume for me."

I told her that I can do it but not every day and only on a romantic night. I do love to wear nice wardrobes in satin and love to wear kimonos also. My friend was shocked to know that we don't have a romantic night every day. She laughed and said that my marriage was probably boring. That's why men look at other women or just watches football because when they come home. This is because a man is welcomed home by his wife wearing pajamas.

I asked if her husband watches TV and she said that yes they watch TV together. Well, at least I can say that I experience that all the time because after eating, we always watch TV in a different room and have some dessert there. That made sense to me!

My co-workers were teasing me all the time they really had a good sense of humor. They said that when you see a man who is always with the females at work it is because when they go home, they see their wife who doesn't care about her appearance therefore they flirt with the female co-workers who care about their appearance more. My co-workers say that they don't do it because when they think of their wife they know that she will be waiting for at home looking very beautiful.

But what I liked knowing more was that the men also does the same and makes some effort to be handsome for his wife. That made sense to me! When a person meets somebody new, he/she would show the best of themselves by dressing beautifully for dates but once they get married, things change.

I really liked my friends who were different from the other cultures. We celebrated a birthday of a Muslim co-worker and again we did not know if he celebrated birthdays. I remember that he was chocking mostly because we tried to hug him but he avoided us. He said: "I am sorry but I can't hug a woman unless she is my wife." He explained that because of his religion and that he is a married man, he can only have his wife can hug him. My friend whispered in my ear: "I hate those women. I wonder what they see in them." My thoughts were different from hers, I felt that it was beautiful and made a lot of sense.

Now what about cleanliness? I met somebody that had a strong smell and my co-workers used to make fun of him. They were on the impression that Muslims don't take showers and I began to wonder if that was the truth.

I learned that my friends take five showers a day every time they pray! Well, today I know now that I was wrong, we don't take a shower five times a day because we only purify ourselves before we

go to pray and if women have menstruation, she should not make the obligatory prayer.

Somebody told me that it was silly because they never read something like that in the Bible! I told her that we don't follow the Bible however, I believe she didn't read the Bible completely because her Bible says in Leviticus 15:19 22:

"And if women have an issue, and her issue in her flesh be blood, she shall put apart seven days; and whosoever touched her shall be unclean until the even." In 20 "And everything that she lieth upon in her separation shall be unclean: everything also that she sitteth upon shall be unclean." In 30 of Leviticus ...and the priest shall make atonements (means penitence) for her before the Lord for the issue of her uncleanness. In 31 "Thus shall separate the children of Israel from there uncleanness; that they die not in there uncleanness, when they defile (pollute or dishonor) my tabernacle that is among them.[7]

In reality Leviticus is a part of the Bible in which the laws and regulations are taught, laws that God wanted people to learn and practice in the daily living. When I read this part I was only sixteen years old and I was very surprised. I was thinking if a woman has a date, they would take a nice shower and dress the best clothes and prepare themselves for the evening. Some women may not want to go on a date if they are swollen with menstruation but if they have to go to the house of God they don't care.

When I was growing up I saw someone reading the Bible in the bathroom. I remember asking why she was doing that. She told me

[7]Place where they had the sacred scripts or place where they pray

that God see our heart. I told her that God may also see and smell you. Why is it that we cannot take our boyfriend or our husband to the bathroom with us because is uncomfortable but instead we allow the One that keeps us alive to take all the bad smells from us? Why not sacrifice and give Him the time to feel our appreciation and our love. Only five minutes in a special place from our home, just for God and him alone, to the one that we ask for help when we are in trouble or when someone in our family is sick or has a terminal illness.

We always invent excuses that He sees our heart. He sees the heart because we can't see him in person but what about the love? Do you love him with the same intensity that you love your date? Why not dedicate some time for him, to our Creator of the heavens and the earth? Those were many of my thoughts during the time that I was looking for that something therefore I was even happier when I found this answer In the Quran in *Al Maidah Surah 5; 6*

"Oh, you who believe! When you intend to offer as salat (the prayer) wash your faces and your hands (forearms) up to the elbows rub (by passing wet hands over) your heads and (wash) your feet up to the ankles. If you are in a state of janaba (after a sexual discharge) purify yourself (bath your whole body)..."

I can fill many pages talking about what made me fall in love with Islam and all I knew were little things except who Allah was because I never heard about him in the Bible. I thought before that Muslim's God is Muhammad [peace and blessings be upon him]. I also thought that because I'm not from the Middle East then I can't be a Muslim.

During the last five years, I thought that you needed to be born in the Middle East, Pakistan or Egypt to be a Muslim. I looked for other religions but none of them gave me the peace and common

sense that I had found with the families that I met in Nashville, Tennessee. I know that there are many people who have the same misconception about religion, God and Islam. The day that I was baptized I said to myself that day: "God forgive me because in my heart I feel for Muslims but since I was born in Puerto Rico I can't be baptized as a Muslim. " That's the truth of what I was thinking on my mind the day that I was baptized in another religion I couldn't even imagine that Muslims don't get baptize.

CHAPTER 14

IT'S ALL ABOUT POWER AND CONTROL

In Domestic Violence

Have you ever been in a marriage where you know that things are not right but you cannot leave? You have the hope that one day things will change but deep inside yourself, you know that there is no hope. You think to yourself, what about the best day and the eighteen years of marriage? As an advocate that I worked in domestic violence I saw it and hear it many times but also I experienced the same feeling.

Well maybe things can change if he moved to another platoon. Other soldiers told him not to take that platoon because it is very stressful but you know sometimes people don't want to hear what other people say instead they want to experiment by themselves and in the end the family suffers.

I decided to leave this topic for the ending of my story because I wanted you to all fall in love with the same person the way that I did. See how easily you can fall in love for the wrong reasons? Many people ask me why I separated from him when he was such a great father, a good provider and seemed like a great husband. The reality was that all his attributes are true but sometimes two people cannot live together. Sometimes we keep postponing because we think that it is the best for our kids or maybe because we can get used to that person or because we think that we cannot make it without that person but in the end, all we do is hurt our children.

What we left in our children's memories are the arguments instead of the best memories such as having their father or mother happy at the end but living in different houses. Of course our children didn't ask us to be born in this world therefore I realize we should be more responsible before having a baby. The truth was that I was only in a marriage of power and control and it was turning dangerous. At the end separation was the best prescription but what about our kids? They needed a family.

My daughter went to sleep just minutes before she heard the same argument yet again. She was only eight years old at that time. To her, he is a great father because when he comes home from work, she is already waiting with all the tools they needed to go fishing. She said: "Let's go now!" Then he said: "Okay sweetie, just wait until I change my boots and get into comfortable clothes." and that was all it took. He is a father who always brought the children to the doctor when they were sick and went with them to the soccer games, judo, or swimming. He was also a Cub Scout leader and a person who does not smoke or drink. What else do they need? He was the perfect father.

I went to sleep an hour later than my daughter who used to sleep beside me. Suddenly I felt the bed shaking and thought an earthquake. I started to call my daughter's name when I saw her shaking. I started shouting when I found my daughter having convulsions then my son came to the room upon hearing my screams. Her father came upstairs and took her to the emergency room and he forgot everything that he knew about first aid because at that point no one knew what to do. I left with only my pajamas on and my husband without his shirt. She was admitted in the hospital for observation. Nobody was able to tell the diagnosis they realized it was nervous and we tried to wake her up but got no response. We were very nervous so we started crying. At that point I realized that we couldn't live together anymore.

What else should a mother need to understand the hurt that she is doing to her children when she stays with a man with whom no matter what she does, things are not working out anymore? How many more excuses? The next day after my daughter finally woke up, my son had his luggage made and said: "I am leaving with my aunt. I already talked to her and I am taking my sister."

Suddenly I realized that he was right. I said okay and thought therefore I think I don't have anything to do with this marriage because my kids are not going to be with me anymore. My son said okay and should let him know whenever we divorce so he will come back.

How blind was I? What made me think that my children needed their parents together? Was it my religion, my parents, the society or just me?

I told my son that we will go next week however I didn't have the money. I then asked about his brother. He told me that once he sees me leave he will go with us but I needed to give him time. I told him that I couldn't leave him here. My son said: "Okay, then we will go. Mum, do you want him to come back? I'm sure that he will leave with us." I said: "Well wait until we have money. Maybe by that time we will be able to convince him." My son told me that he could sell his radio equipment and my daughter, who was quietly listening to the conversation, approached with her piggy bank full of her savings. Her quiet action talked more that if she said anything.

It was a sunny day in June when we left using our van. I remember asking myself why my heart felt so heavy and dark despite the day being so sunny and bright. Before we left my husband came crying saying he did not want me to go. My son asked: "Don't you think that we will miss him?" I cried and said: "No I am not ready! It's eighteen years of marriage!" Suddenly I looked at my daughter and I remembered how panicked I was when I saw her days before. I

asked myself what would happen if I left. Will I miss him? Yes. Would I cry? Yes. Would I be happy? No. I would not be happy now. What happens if I stay? Can things change? I thought about how much we disrespected each other. How my self-esteem and his self-esteem got very low. I pictured everything in the past, and realized that nothing will change. Will I be happy? No, I will not. Therefore, if the two answers were the same and neither of them changed the results, then I had to concentrate on which one will make my children's life better Being alone, I had to try to take every day at a time and pushing myself to the limit. Sometimes, when I wanted to go back from Tennessee to Georgia, where he was, I asked myself the same question, am I going to be happy? Is this going to help my kids have a better life?

My two children and I left and moved from Georgia to Tennessee. I didn't know what was harder for me if getting my life out of the military life or been far away from the man which whom I spent half of my life. I was a totally dependent woman. I didn't even know how to do groceries since he was the one that used to do it. But I knew that my children were going to have the peace that they deserved. I couldn't give that peace to their older brother. Therefore he was living with another family. Leaving was very painful to him and me many emotions were involved he started begging, crying and finally as the van was leaving he told me: "You're never going to make it." Have you ever heard that before? If you did, ask yourself the same questions that I asked myself.

There was sometimes on my life in which it would it be nice to know that there are shelters for domestic violence. However after I began to work as an advocate for domestic violence I realized that my life with the father of my kids were not bad only after the divorce was getting very ugly. Some women don't know about that, of course in my case, I didn't have the same issues like other woman's that I knew. My problems were more about other kind of control. Today I can say that in the beginning it's very hard but time cures everything

and heals all wounds, don't wait like I did. When a relationship doesn't work since the beginning then it will never work.

Eventually he moved to Kentucky and at the end we were near each other. Later things were different because he changed from the stressful job that he was having. However we were not able to understand each other better because we kept arguing even though we were living in separate houses. What made us be this way? We both knew that we were good people. I considered him a great man and he considered me a great woman. Later, when we both faced a problem in our family, we become one and when I was diagnosed with cancer, we become one. I left my house and remarry him.

We become more like a brother and a sister as if we were two family members who needed to share the house at the base. This time my intention was not to leave. Living in separate rooms, sharing the same house make things calm for a few years. In reality this time my intention was to stay forever why not? I had everything in my life, companionship, love, stability, someone who takes care of me, and the best of all, I learned how to work; but, God had other plans for me. Later, the war came and after all I converted to Muslim, few years later our second marriage end in divorce.

I realized that sometimes we woman think that only because we are woman we are the only one abused. We think in the things that our partners do to us but we never think in the abuse that we also can do. Respect, or the lack of it, comes from both, man or woman and sometimes when two people cannot be together the abuse is from both parts.

~*Important*~ When we are born, what determines our life is our upbringing and the atmosphere which we had as a child. When you start living with someone from a different family, it makes you change and become the other one. Be careful when that happens because you might be involved in power and control. He might tell

you the most beautiful things one day, he makes you depend of those beautiful memories he might buy you gifts and when he thinks that he has you completely one might

Assume that all is perfect, and then he attacks you again He will be sweet again until he keeps getting your soul again and again. This power and control is like a circle It affects people from different backgrounds, cultures, and professional or not. And once you are in that syndrome, it is very hard to escape.

Today in this technologic era any person can be a victim of domestic violence. More people met in the Internet, looking for that "soul mate" that promised a "heaven", for some the relationships might work, but to others might be disastrous. People who find "love" in the Internet are open to be used because of the "beautiful words" and promises. The other person creates any argument it's all about to keep the control, after all they know that the victim is able to do anything just to "keep" the relationship. They end losing everything, Ones personality, the dreams, or your life. . They will use the tactics of the pimp the woman will do anything for him because she doesn't want to lose him. Then he will come back and will be nice to you a few months until he will start another argument. If this happens to you, get help. This is a syndrome, the syndrome of domestic violence. If this happens just be far away from the Internet and remember time cure everything. If it happens between couples don't feel guilty, if you cannot leave for the sake of your kids, because it is like a disease, it is not your fault. But if you get help, time will open the door for you and you will find freedom. You must start the first step and it will just take one step at a time.

Islam is less complicated and a lot different I can say that trough Islam I learned what was my mistakes on my marriage also a mediator comes to help the couple. It can be your father or your brother. Divorce is also allowed in Islam. Sometimes there is a misunderstanding easy to fix if someone just talks to the couple. The

suggestion I give to the women that just convert to Islam is to learn about her religion and her rights. Many American women marry Arabs through the Internet and later convert to Muslim but they don't know anything about Islam. They don't know that a Muslim woman can get a divorce or go to court and get divorced in their country because of domestic violence.

What makes me mad is that they immediately take their hijab out start talking about a religion that they never knew because their husbands, who were supposed to teach them, did not want to do it. The reason for this is because they only want to have the entrance to the United States. Therefore I will suggest to never marrying a man you just met from the Internet. If he is a religious man, then he will find a Muslim woman through the mosque. I am not trying to say that all of them are bad men because in many countries most men cannot have a good job therefore the easiest way is coming to the United States. I know marriages that are very happy for many years and the man never left even after getting the residence but how can you know that the one that you are talking wants to do the same? Therefore don't take the risk.

I found a great definition about power and control: "Control is the power of being able to direct something. Power is the control over something. Basically, control needs power and power needs control in order to work." This is used in every aspect of our lives. A boss can do that, parents can do that, sisters and brothers and governments also *in Politics*

Before September 11 2001, to be specific, around August of the same year, I was invited to a wedding in Egypt. I had plans to go with my daughter and after that we wanted to go visit my sister in New York. Instead my daughter decided to go to Puerto Rico to spend time with her cousin. I used to talk about the towers in New York and even had many pictures when my kids were little. New

York was my favorite place in the world. I felt frustrated later because my daughter never got to see that place.

I wanted to find out more about the Islam religion. I was disappointed with anything that had to do with Muslims. I felt disappointment, anger, frustration, and asked myself if what Islam teaches are for real? Why do terrorists kill people in the name of God? Why do people commit suicide? Does the Quran promote suicide? I tried to look for information about all the things that happened in the world. Well, in reality I am familiar with the word terrorism already since I was a little girl. I remember when I lived in Spain, I used to hear in the news about a group that were not happy with the government and that they were terrorists. I was always afraid of them when we used to go to the market even though they were far away from us but when you are little you don't understand those things.

I remember what happened in Oklahoma with Timothy Mackvey. I'll never forget how sad it was to watch the news and learn about the day care that was near that explosion. It was very sad and scary to learn that this happened in America and done by Americans.

What about all the dictators in history such as Hitler? Should we call all Germans as Nazis the same way that people say that all Muslims are terrorists? How many dictators are there in the human race and how many more will come because it is what is written? Who knows how to talk perfectly and have the ability to convince people to be able to raise followers and believers? Many things happened in history but everyone easily forgets.

How many people died in the Crusades? What about the war that were patronized by the Pope to establish Christianity against Muslims or anyone else who was not Christian? We talk about Muslims being terrorists but we forget that during the time of the Crusades, Pope

Urbano offered everyone the forgiveness of sins. He offered rewards in this life and the next life if they went to kill in the name of God by fighting against Muslims.

I wondered how that Pope knew that God wanted people to fight against Muslims. What about other massacres that happened in the world such as Pearl Harbor, Hiroshima or when the American Japanese were sent to relocation camps? What about the KKK or the Red Scare? There is so much in the history that just repeated itself. How many more fights with the only purpose is of the establishment of power, race or religion? Scenes like what happened in Teheran were known all over the world and might happen in some Muslim countries but are that what the Quran says that Muslims should follow? Perhaps nobody read when the people from Morocco were prohibited to be Muslims and entire families were killed if they found someone doing a sermon on Friday. However during the times of the occupation of Muslims in Spain, they entered the country more as liberators and not as oppressors. They were good towards people from different religions. Christians, Jews and Muslims lived in peace and everyone was able to follow their own faith. They lived according to a verse in the Quran *(2; 256)*

"There is No compulsion in religion. Verily, the right Path has become distinct from the wrong path. Whoever disbelieves in Taghut, (taghut means believe in other than Allah, like saints, deities, devil worshipers etc) and believe in Allah, then he has grasped the most trustworthy handhold that will never break. And Allah is all-Hearer, All- Knower.

Muslims are severely judged for what terrorist does or what someone who don't understand the Quran reads and interpret without having the proper knowledge. The suicide bombers are wrong, however we are all wrong in thinking that is all about religion and they are hoping to go to paradise while thinking that they are martyrs, what many people don't know is that many of these groups

try to recruit the ones that they know that are not well economically, therefore sometimes there intention might not even go to "heaven" but to help a family in a country in which they might be hungry. This is an issue of the Governments, poverty. There is several verses in the Quran that mention that suicide is a sin, as well as killing a human being is condemned with hellfire, like the first crime of humanity made by Cain remember that story? In Sura 5 Al maidah 32:

> *"Because of that, we ordained for the children of Israel that if anyone killed a person not in retaliation of murder, or and to spread mischief in the Land it would be as if he killed all mankind, and if anyone saved a life, it would be as if he saved the life of all mankind .And in deed ,there came to them our messengers with clear proofs ,evidences ,and signs ,even then after that many of them continued to exceed the limits(e.g. by doing oppression unjustly and exceeding beyond the limits set by Allah by committing the major sins)in the Land!"*

Therefore The Lord is very clear of what he want from us, but people love to find excuses to commit all kind of acts. This verse is very clear and similar to the verse in the Bible that kept me in doubts all my life because I felt that it was contrary of what God wanted from us.

Therefore this entire calling for war is not only found in the Quran but also was for the sake of one Lord fighting for the establishment of religion and power. In the end Christianity was established and perceived as normal. Of course today we Muslim should never compare the Bible to the Quran the only reason why I do it is because this where the things that made me wonder and search for something else, therefore since I know that many people might be in the same situation I expose them.

I often asked myself that if it is true that the Quran only instigate to make war, then what should I think about all the things mentioned in the Bible?

GOD WORKS IN MYSTERIOUS WAYS!

My son followed his father steps when he decided to join the army at the age of eighteen. I was not happy with that decision because I never liked young people joining the army.

Like my father, I wanted my children to go straight to college and I knew my son himself dreamed to go to Harvard one time however it was not possible. He thought that by joining the army he would find a way to go to The University. After taking some college classes a recruiter convinced him to join the army.

Like many others at his age, he thought that it was the best way to get grants but Allah had something different prepared for him.

He was in an Army Base when he found his faith in God. Before his conversion, he also tried different religions and started looking for answers and peace that he never found before his life with The Army.

Islam teaches me that we all born Muslims until we choose the religion that our parents taught us. I considered the story of my son with The Army as one of Allah's mysterious ways. I remember the times when I used to bend my knee to pray because my son was in a religion that didn't believe in God. He was a pagan and I supported him in a way. He was an adolescent and as I mentioned before I always tried to give my children the freedom of choosing a religion, but the truth was that I was hoping that one day he would change. I prayed every day for this. Until one day a priest told me what I read many times in the Bible. I didn't realize that I was a pagan myself because I was very obsessed with the rosary. Proudly I mentioned that I pray the rosary three times a day. He advises me to be careful because that might not be what God really wants for mankind. Surprised at his words, I asked an explanation. He explained to me that I was dedicating more time to the Virgin Mary

than to God. He said that it was a Marianas principle, it was not what God wanted and it could be a sin to love Mary more than God. I can say that he was one of the reasons that motivated me to read the Bible deeply. I started to pray more to God and prayed the rosary only one time a day, after that I make a "prayer" to God. I used to ask him: "Please Lord, do like you did with Pablo he was an enemy of the Christians and later become one of them. Please make my son bend his knee to you and adore you! If he doesn't do it I gave him to you, he is yours whatever you please do to him! Keep him in your path. We went through hard moments after my son join the Army, but I always believe that after a bad moment a good comes."

One day when I went to visit my son, he told me that he was looking for a religion and that he was going to the service of one of the church. He was wearing a rosary and told me very proudly that the Pope blessed that rosary. I went home very happy. After a few months I received a package at my home with his Bible and the rosary. I started to get nervous and thought that something bad happened to him but inside there was a letter from my son: "Mom I want you to know that I converted to Muslim. I hope you don't get mad at me." I started to cry, bend my knee to the floor and gave thanks to God: "Thank you Lord, thank you. God works in mysterious ways!" Then I realized that if my son, who was not an Arab, converted to being a Muslim then that would mean that I can also convert to Islam. Wait a Minute…he is my son…his mother is not a Muslim!

My son told me: "Mum, Alhamdulillah [praise to the Lord], I passed through hard times because I was going to meet Allah."

His story is one that I might write one day but for now, I wanted to write about my conversion to Islam and how I finally decided to change my life.

For a mother, her children are the best in the world and often see them with very special eyes. Any mother wants the best for their children and for other mothers they would want their children to have a great career. When your kids have achieved a great place in the society, people say that their mother did a great job.

I was not looking to have that special place through my children because I only want one thing from them and that is to accept any race, any color, and any human being sincerely from their hearts. I wanted them never to think that they are superior than anyone to the point of treating others like they are lesser. I wanted them to be independent in case they find themselves alone. I wanted them to tell me the truth no matter how hard it would be for them and for me. I wanted them to respect other people beliefs, the way others should respect them. I wanted them to be themselves in front of other people and not to hide under a different personality.

I am very proud of each of my kids because I believed that I achieved what I always wanted and that is to give them an easier life. I knew that by respecting others, they will be happy and that was the most important goal for me as a mother. My son was only eighteen when he join the Army I was Catholic at that time, I felt that he was very young but a recruiter convinced him that it was a Great decision. To me was not. When he had problems with the Army I remember that I prayed to the Lord, "Oh Lord… please send me a sign even if I believed that my son was innocent, but that only God knew. I knew my son and therefore believed him but I did not want to be like the mothers that just believed what their kids said I wanted a sign. I prayed for a long time on my knees. Please send me a clear sign I want to know the truth."

The next day while I was watching the news, there was a story about the Pope who was going to another country to canonize a Saint. The name of the Saint was the same name of my son and the country the Pope went to visit was where the person trying to get my

son in trouble was from. I immediately remember my prayer it was clear sign I felt that my prayer was answered. During that time, I did not believe that a saint could do me a favor. I didn't pray to a Saint to intercede for my son but I still felt and think that the Lord answered my prayers in the only language that I knew at that moment and that made me confident enough to ask another petition through prayer. I asked God to fix my heart.

I was diagnosed with a congestive heart failure for three years and was taking three pills. Every time I visited my doctor my health was worse he would say: "If you keep gaining weight, next year I'm going to see you in a black box." I joked: "Why a black one? I would love to be buried in a white one instead." I prayed with faith because I wanted to be healthy. I knew that my son Military Base was far away from us, he needed me to support and visit him. He was station in a Base known as very racist. Therefore he wanted to go to a different area but he never succeeded in his effort. His father and I used to drive fourteen hours to see him every three months. In the beginning we felt that his faith was strong however as the time passed, he began to lose faith.

I remember that I used to tell him about a therapy that I invented when I worked with kids that belonged to the State. The kids would become frustrated and would then become violent when the custody they wanted were denied by the judge I would always calm them down by saying: "Get a pen and a piece of paper. Write the numbers from one to a hundred." I always believed that a person could live to a hundred years if we take care of ourselves and if it is the will of God. I continued, "Now erase your age. The next numbers after the one that you erased will double those years that you passed. This means that the next years can be even better. A year has twelve months and each month can be better. We did it together and after the twenty that he was already he had eighty less. When I taught my son about this method, he felt motivated and began to take college classes. During the time that he was far away I

was never able to sleep or enjoy a meal. Only a mother can understand what I felt.

I prayed with a strong faith: "Oh my Lord, I know this is a test, allow me to pass the test and be with him alive. I was mad when he joined the Army but you knew how he wanted to go to a military institute in Mexico and then to Harvard. He had good intentions but he suffered a lot in his life. When he decided to join the army and do something good with his life, you sent him a trial. We all accepted the trial. I only ask that you allow me to live longer because my son needs me more than ever."

The next day when I went to the doctor, he made an echo and told me that I don't have congestive heart failure and that it probably was a wrong diagnosis. During those three years, I was taking three pills and feeling funny but now I have two different results in my records. Praise be to the Lord!

A year ago, my son came by my bed to say goodnight and we ended up talking. Mum... is truth God work in mysterious ways! He finally fell asleep; I sat there looking at him sleeping soundly. He is now thirty-one and has been happy living on a Muslim country for many years now. He lives a peaceful and successful life as a Muslim. Praise be to the Lord!

CHAPTER 15

I AM A MUSLIM NOW!

*O*n a beautiful day in November, my husband was in the war while my younger son and his wife decided to stay in the house with my daughter while I went to visit my older son. It was Thanksgiving Day and I felt that something good was going to happen. I believed that after everything seemed so dark or a door closes, somehow another door opens and the light comes in. I resigned from my job so all I had with me was two hundred dollars but I knew that it was enough money to go and come back. I owned a house during the time that I was separated from my husband.

On my way to Oklahoma, the lady of the mortgage called me and said that if I don't have the money to pay on or before twelve noon, the bank will take over my house. I decided to leave everything in God's hands. I did not know it but it was exactly what a Muslim should do by leaving everything in the hands of Allah. I was invited to eat with the Imam and his wife on The Army Correctional facility, When I arrived I turned my cellphone off. I remember I saw some soldiers from Egypt. They stayed in the same hotel on the military base. I always dreamed about visiting Egypt, but my intentions were different of what The Lord wanted from me. I was thinking: "On my way to the room, I am going to invite them to the party that is on post."

After we ate, we went to the Mosque then the Imam suddenly said looking at me: "I know about someone who avidly wants to convert to become a Muslim. I ask this person, what stops you from become a Muslim?" My cheeks turned red but I responded immediately: "Nothing, I am ready. I have been ready a long time

ago." I know and believed deeply that we should worship only one God and that the Prophet Muhammad (peace and blessings be upon him) is a messenger of God. I said to myself that I am ready today. Thinking that he did not hear me, I said louder: "I am ready now." He said: "Ok, I see that there is no doubt that you are ready, so repeat after me." After I bear witness that there is not God but Allah and the Prophet Muhammad [peace and blessings be upon him] is the messenger of Allah. He said that I just offered my Shahada therefore I am now a Muslim. I felt at that moment that my whole body approved what I was doing my intentions were genuine, I felt the must happy woman on earth I still did not understand the commitment that I just made, when a Person offer their Shahada is a Big commitment not mere words. But I learned after many years of been a Muslim that many people don't realize the importance of those words, like me I was thinking to go and have fun on a party that was on Post.

I saw my son's tears and he hugged me very tight. The Imam's wife hugged me too. I kept telling to myself am a Muslim now! It has been many years now and yet I still cry when I remember that day. Everyone congratulated me and I felt that I was having a beautiful dream. I thought, now I must learn a lot. I thought that I had to learn Arabic. I still had misconceptions about Islam but very slowly I learned many things and realized that being a Muslim was even better than what I thought.

The Imam wife told me that all I needed to learn is how to purify myself before going to pray and how to say the prayers. I was so happy that I forgot about my house. When I was on my way home, I turned on my phone and saw three messages. "You can keep your house because someone called and paid what you owed. My nephew, the one that lives in New York, someone who is always in my prayers and will always be grateful for, paid for my house. The other two messages were from my job. Alhamdulillah, I had the opportunity to go back to my job but in a different program. In reality when I gave

my resignation, I was told that I was going to work part time in anther program but it was not until next month that I was supposed to start. I am a Muslim now. I still feel the sensation of peace that I felt at that time. It is a feeling of no worries about anything because I know that I will be taken care of throughout my life.

I felt confused because when I went to the Hotel, I tried to talk to the Egyptians but they talked very differently to me. Why don't they talk to me now? I was even thinking to invite them to a party! At the moment that I said my Shahada, I did not know many things but as I kept learning my life changed for better.

The things that I thought that I knew about Muslims were nothing. I understood why people don't know this religion very well because the books in the library don't show what real Islam is. They said that this is a religion just based on men but what I see is that it helps the female more and also protects men. It is all about family and everyone in the family has rights.

The kids will be happy to know that if I go to their room, I must knock first. Of course that is etiquette but sometimes as a parent, we think that we can enter into our kid's room without knocking. One of the things that I liked is that if I must visit someone even though she is our daughter, we should let her know before we visit. It is not a simple etiquette that I can forget because if I visit her and she doesn't want to open the door, then I cannot complain because I did not let her know in advance. This was something I loved. Being a Muslim is a big change of life, therefore if you live around Muslims for long time it is very hard get used to being around people that are not Muslims. Islam is not only a religion but also a way of life and must put in practice what Allah sends us to do.

I read that Muslims must study their religion and even the little kids learn the Quran. We must also learn the Sunnah. "Seeking knowledge is every Muslim's duty." However the most important

information I learned was to find out that I didn't need to be born in the Middle East to be a Muslim. I learned that Prophet Muhammad (peace and blessings be upon him) was very humble and he did not like oppression. In *Al-bukhari*:

> *"The Prophet (peace and blessings be upon him) said, Whoever believes in Allah and the last day should not harm his neighbor."*

I was happy to find out that the Lord gave us free will and didn't want anybody to carry our sins. He is so merciful that He didn't think it is fair that if I sinned, my kids must pay for something that I did. I wonder why I was always afraid that my children will pay for any of my sins but after I read in the Bible in *Deuteronomy 24:16*: "Don't kill parents because of their children's fault" and in *Jeremiah 31:30*: "Everyone will die for their own sins." My confusion had a lot to do with the idea of Jesus dying for our sins. What clarify me in the Quran, the most important book to me, the last sacred Book sent for the Humanity, in *Surah 4 an – nisa 111*:

> *"And whoever earns a sin, he earns it only against himself. An Allah is ever all knowing, all wise. 112 And whoever earns a Fault or a sin and then throws it on to someone innocent, he has indeed burdened himself with falsehood and a manifest sin."*

That is what it shows a Merciful God to me. The idea of the "selfish God" that allowed his son to die in the cross was not right to me and make me live with doubts all my life.

I also read a long time ago, women were mistreated because of Eve's sin. "The word "human" meant only the men. The Jews called women "a born sin" because she was considered to be responsible for the exit of Adam from heaven. I also read that the Quran came to give her rights and a status of equal to men. My question all my life was answered: it was not just Eve's fault. Adam was also guilty for his sin because of free will. Is like if my son is grounded and I tell him: Don't go to the neighbor" but on my absence he disobeys me. When he comebacks I am mad at him: Why did you leave? And he respond it was not my fault the neighbor son pushed me to do it insisting, I then answer, but who is your mother me or him? Who I have to punish?

I remember that I never understood why people who were guided by God started making a God that they can see or touch when Moses was in the mountain. They were supposed to be people of faith. I learned that we tend to have the necessity to see or touch an image in order to believe. What confused me all my life when I read the bible *(Exodus 32:1)*

"And when the people saw that Moses delayed to come down out of the mount, the people gathered themselves together unto Aaron, and said unto him, up, make us gods"

Deuteronomy confused me every time I used to read that we were not supposed to worship idols. I felt that something was wrong in the Religion that my parents taught me and I felt that no one should ignore these verses like people were doing. The Bible, *Deuteronomy 4; 15 to 16*:

"When God spoke to you from the fire, he was invisible .So be careful 16 not to commit the sin of worshiping idols. Don't make idols to be worshiped whether they are shaped like men, woman 17 animals, birds, 18 reptiles, or

fish.19 and when you see the sun or the moon or stars, don't be tempted to bow down and worship them.

Finally my doubts were cleared with Islam. Alhamdolillah [praise be to the Lord] I am a Muslim now! I stopped reading the bible completely.

DIFFERENT WAY TO LIVE

I once asked my grandmother what faith was and she replied, "Faith is believing in what you can't see." I kept thinking about what she told me because she had a big picture of Jesus with blond hair and green eyes in the room. Later I asked her, "But if faith is believing in what we can't see then why do you pray to those pictures?" There are pictures with him in blonde or dark hair but nobody really knows his hair color. Whatever the answer may be I don't need to go back and find it because the Quran answered all my questions.

This was another important question that I had ever since I was little. I kept thinking that Jesus was a human being, but how come he was God? I was afraid to ask this question because I knew that it had a lot to do with faith. I was not an Atheist because I believed that there is a God but I guess I did not have the same faith that my Grandmother had. However, I felt happy when I found out that Jesus [peace and blessings be upon him] was one of the most beloved prophets of Allah and that Maria, who was twelve years old when she had Jesus, was prepared to be his mother even though she was just a child as well. Through a miracle, she was not touched by any man and gave birth.

When I read about the origins of the Bible, I was shocked. I loved reading about different Theologies in history books so what I

learned about the Bible was from the bible and not from Islam. I discovered that different men with different concepts made the Bible and translated it from the original language to be kept by forty men who were supposed to be inspired by God.

However, through reading I discovered things that I never imagined I could find. The information I discovered was about some theologians. Moris Hoblaj, one of the theologians, said that the Bible was created according to the church. In the year 380, Jerome was forced to write about the Bible according to what should only be written, anyone who wrote differently or was not a Roman Catholic would be sentenced to death. Sometimes it's even questioned if what they wrote about Jesus's death was real. There was much incongruence in the Bible and a lot of the papyruses[8] were lost.

What made me believe in the Quran was that once it was revealed, the original was kept at its purest form and language. Overall, the Prophet Muhammad [peace and blessings be upon him] was alive during part of that time. How is it that a man who was illiterate was able to read when the Angel Gabriel told him to read? How is it that he could come up with such perfect creation unless it was a miracle? The Prophet memorized the Quran after Angel Gabriel revealed it to him. After it was memorized and recited to people who were able to write, he also taught it to his companions. I looked up the meaning for the word Quran and found that it meant "recital"; as a result, I had no choice but to believe.

In order to be a Muslim we must also follow the Sunnah, which was the way the prophet lived his life and could be found through the evidence in the hadiths, historical reports of the sayings, actions,

[8] Papyrus is a writing material used by the ancient Egyptians, Greeks, and Romans made from pith or stem of a water plant. *2012, Encarta Dictionary.*

and examples of the prophet. Every action of the prophet was observed and kept by his companions. They would annotate such actions like whenever he prayed or whatever he did and was taught through generations as of today. Keeping the Quran intact was something very important for his companions and Muslims throughout the generations. Right after the Prophet's death (peace be upon him), the people had compiled the Quran in other dialects. This had caused some confusion along with the fact that some people did not have the complete Quran compiled. Abu Baker as Sadiq, friend and companion to the Prophet at the suggestion of one of the Companions, collected every copy the Quran that was available. After a committee of Companions who had memorized the whole Quran and had written them down compiled the Quran without any alterations or mistakes. All the defective copies were destroyed and the original was mass produced in order to protect the authenticity of the Quran and keep it from being manipulated as the previous Books had.

Such action confirmed the purity of the Quran and that we are only one community all over the world. I loved to learn about that piece of information because it made sense to me! People talk and talk about Muslims, why is there so much exaggeration with the Quran?! Why? The Quran still has the same purity of when the Lord revealed it to Angel Gabriel for the angel to reveal it Prophet Muhammad [peace be with him].

There is another important question that was answered and that helped me decide to convert. I went with my friend to see a movie about the life of Prophet Muhammad [peace and blessings be upon him] because I was curious to know the image of the Prophet [peace and blessings be upon him]. I asked my friend if we will see the actor. My friend told me that there is no actor to see. I was very confused because there was someone talking as the Prophet. She laughed and said that was the idea because if we have an image, then

people will tend to adore the image as if he is God, instead of looking at him like a messenger of God.

This sounded very realistic to me and it made a lot of sense. Do you understand now why we can't have any caricature of the Prophet Muhammad [peace and blessings be upon him] beside the fact that it is considered disrespectful to do have one for any prophet? Can you imagine how repulsive it would be to see any caricature of our beloved Prophet Jesus [peace and blessings be upon him] doing something wrong like smoking marijuana or something like that?

Some people tell me that it is all an exaggeration when people get mad at the jokes that someone made about the caricatures of Prophet Muhammad [peace and blessings be upon him]. I used to think that it is all about disrespect, but I realized now that is all about ignorance. This is why Islam is a way of life because it teaches the servants of Allah how to respect what is coming from him. When our kids are sick or have a family member that is about to die, we have so much faith when someone tells us that they can be cured with a piece of cloth. If someone says that a person can be cured if we go running without shoes, we would do just that. Hope is the last thing we have at that moment and nobody will laugh or joke about it.

When I converted to Islam, a person from my job made a snide remark by asking me if I was in the same religion of Ali Ba Ba then did a reverence and knelt with his hands while saying, "Ali BaBa, Ali BaBa." When we kneel we say, "Glory be to You My Lord" or "Glory be to My Lord, My highness." How can a person make fun of something like that? We don't joke when we pray. Why can't people take things that come from God seriously?

Many people make money just by talking about the bad experiences they encountered with Muslims. Now ask yourself, would you like to be judged for what a member of your church did or for the wrong things people from your congregation do every day?

We are just human beings and the devil is there waiting to see us do something wrong. Should we think that from twenty people there, maybe only two made the mistake or maybe the opposite?

I have friends who are not Muslims but are very special people. They like to help people or do charity. However, I decided to keep many of my friends far away because they might not understand my newly acquired customs. I thought that it would be hard for me or them and found it better when I am far away from the people whom I cannot share my life; because Islam is my way of life.

People get offended when they invite me to a birthday party or try to give me a gift in celebration of my birthday and I tell them that I don't celebrate birthdays. We must have friends within our religion because those who don't understand our faith might joke about it and may not understand that it is offensive of our beliefs of the Lord. They might say the same joke over and over again. We may feel weak and not say anything, but in the end it makes us very uncomfortable and unhappy.

This is what the Quran says about that, in *Sura Al maidah 5: 57*:

"O, you who believed! Take not as Auliya, (protectors and helpers) those who take your religion as a mockery and fun from among those who receive the scripture (Jews and Christians) before you, and nor from among the disbelievers; and fear Allah if you indeed are true believers. "Of course I still keep my friends that are not making fun of my beliefs because they are showing me not only that they respect my beliefs but also they respect The Lord.

After I converted to Islam, I was sitting at the break room at work and was listening to all the conversations where everyone was talking about someone else's life. I felt that it was the longest hour I've had in my life. On that same day, I was invited to a sister's house

because her daughter was graduating from college with a bachelor's degree. I was in that house for five hours and we were all females.

I didn't want to leave when it was time for me to go. It seemed that the time flew by so fast. None of the sisters in that house talked about anyone else's business because they didn't want to get in trouble with Allah. We are sisters and we are supposed to love each other. We did not talk about a certain wife being unfaithful to her husband, or the lover of someone else, or someone who bought the latest fashion designer shoes but instead we talked about interesting things. One of the sisters was a pharmacist and she shared about how long the food should be kept in the refrigerator, another was a psychiatrist and she shared the problems that people face when they have communication problems, especially couples. She emphasized the importance of communicating our feelings to our partner, and also how important it is to use that tool in our lives.

We all talked about our kids like what they were studying and the things that make us happy. Everyone was listening in a positive way and nobody felt offended or competitive. It was like a real family that never gets offended if you talk about the achievements of your children because they feel that they are also a part of it. They are happy during the good times or sad for during the bad times and it made me feel very happy and complete being around the sisters, sharing our experiences. Just knowing that nobody felt any competition or envy, gave me the peace that I was looking for.

That is the "SOMETHING"! That is what I was looking for! What I was told all my life about gossiping, false testimony, the teachings of Jesus [peace and blessings be upon him] about to love one another. The way Islam reinforces how Brothers and sister in Islam should be; a big difference to the religions that I used to follow. Respect for our prophet. The fear of the Lord until the point of not mentioning his name in the bathroom or making jokes about him. How carefully was The Sacred Book, the Quran made. How

Prophet Mohammed perfected the religion for us, like he said in the last sermon, with rules, laws rights for everyone, marriage, children orphans. He revealed how Allah was for us so that we may know him really well. He revealed how was the unseen world, the angels, the heaven the hell fire, and instructions for us not to fall, the answers of why our life felt miserable sometimes in a way that we think that Allah is not fair with us. That information was not taught in the Bible. I never knew why I felt depressed or why I felt lonely.

 The great feeling that Muslims had a "book of instructions" on what made life easier gave me deep thoughts. After reading the Bible throughout many years and observing how people would go out to drink on Fridays and fornicate, there was not doubt this was the religion for me. Adultery was so easy for people that considered themselves of "good faith". How after listening about God some love to talk about the way a person were dress in the church? The answer of why people would act a certain way, even Christians who are considered so "close" to God yet would sometimes be stingy, selfish, or gossiping, were the things that made me wonder all my life. What are they missing? Why do they act that way? I found that answer in the Quran. Therefore it made sense to me that since no one listened to what God wanted through Jesus, the Lord sent Prophet Muhammad [peace and blessings be upon him] to put all the teachings of the Lord into practice. With Prophet Muhammad I saw action.

 I learned that we need to greet every Muslim we see with the words: "Assalamu Alaykum [peace be with you]". The other person must answer: "Wa alaikum assalaam [and upon you be peace]." This is a reminder for us to never forget our love for our brothers and sisters. A time for us to put into practice what makes the Lord happy. To love him first and show it to him by following his commands with a sincere heart and then to love what he loves or hate what he hates. How we can deal with the human being to love

and help each other? Being able to recognize and differentiate our dressage makes sense to me because in that way brothers and sisters will be able to recognize, greet, and help each other.

In Sura 6 Al An'am54:

"When those who believe in our ayat (proofs, evidences, verses, lessons, signs, revelations, etc.) Come to you, say "Salamun 'Alaikum" (peace be on you);your Lord has written (prescribed) Mercy for Himself, so that if any of you does evil in ignorance, and thereafter repents and does righteous good deeds (by obeying Allah),then surely ,he is Oft Forgiving, Most Merciful."

The way women cover themselves also made sense to me because if you think about it when a woman or a wife wants to have a "special night" one wears special clothes showing off some parts of the body. Therefore, can you imagine the distress that men suffer every time he sees a female in the street or the mall at work showing her body off the way women do? Islam mentioned that there should not be mixing of genders unless you have a protector because when genders mix there is a third party between them, the Devil. This reminds me of Adam and Eve again!

With Islam I learned that between a man and a woman the third person is the Devil which makes sense to me, because I see how people who were not friends or dislike each other after spending time alone in different situations become friends and then get marry. I even remember when I was fourteen in Spain my sisters used to have a friend who become pregnant of someone who did not like her as a woman the Prophet (Peace be with him) said:

> *"Whenever a non-mahram man and woman meet in seclusion, Shaytan (The devil) is definitely the third one joining them." (Tirmidhi)*

I must admit that is true. When men see a woman in the street she looks so tempting like a fruit, but if the man touches that fruit he condemns himself with at least ten years in prison. Who's the one laughing about that? Satan. How many men are looking at you in a different way? Thinking whatever about you and having very disgusting feelings? Do you know how many? No, because you never see them but they see you and maybe they had a nice dream with you all night.

In Islam, we cannot judge anybody for anything; however, there is a description of what a hypocrite is in the Quran. I cannot say that a person is not going to heaven because that is a sin. We cannot pretend that we are God. He is the one that can see everything and not me which makes me feel free. My friend once told me that it is a serious matter to judge anyone in Islam because everything is done with a witness. When there is adultery both books talk about sentencing death by stoning but in Islam, you must be sure to have evidence.

There should be a witness because stoning is not that easy. A person accusing can be punished if it was determined that what the accusation was false. We do use judgmental thinking with what we say or where we go because we should take care of ourselves as a Muslim and take care of our reputation in order not to engage in things that displeases Allah. We should show people about Islam through the way we act. I learned that Islam means submission to God and that is also a way of life. If you are sick, you give thanks to God because he decided our life, therefore, we must leave our life in God's hands.

The Prophet Muhammad [peace and blessings be upon him] was a simple human being and he was a servant of Allah, who was

meditating when the Angel Gabriel came to him to reveal the first surah of the Quran. What is strange from all of this was that the Prophet Muhammad [peace and blessings be upon him] was illiterate. He did not know how to read therefore this was one of the miracles given to him for the people to believe because everyone knew he was illiterate. When the Angel asked him to read, he kept saying, "I cannot read" but after three times he began to read. This made sense to me because only the Lord does miracles. The Quran was memorized and written during his time. The Bible was not recited by Jesus rather it was written after he died when a few men recollected some information and in the end some pages were changed according to the predominant religion during that time in history.

Slowly, it became clear to me that I chose to have that peace in my life by no longer being a slave to fashion or pleasing others. I wanted to be loved and accepted by the sisters and respected by men. The book I was going to follow was the Quran and the teachings of Prophet Muhammad [peace and blessings be upon him]. My way of life was going to be the Sunnah and Islam as my religion. I was going to be a Muslim. All the questions I've had all my life were answered and so to Allah I submit. I learned that Allah in Arabic means the Lord, or God in English. I also learned that it is a monotheist religion, meaning that we believe in one God and the only God that every human being should believe in.

A fact that is very important to know is that in order to convert Islam, we do not believe in getting baptized. Instead we offer our Shahada, which gives us many blessings. We say these words:

"I witness that there is no God but Allah and the Prophet Muhammad is a messenger (peace and blessings be upon him) or a Prophet of Allah."

This is totally different from what many people think about Muslims; the idea that Muslims only believe in the Prophet Muhammad [peace and blessings be upon him] as our God. When we offered our Shahada we must do it from our heart; it is not mere words that we say. Such action is a commitment in which we compromise that we want to worship only Allah (the Lord) and that we accept Muhammad as our prophet. We not only accept Muhammad as a prophet but all the prophets that were sent before him. We believe in the angels, in the hereafter, in the decree, or destiny, written by Allah. Finally, I was able to understand what Islam was.

In Sura 6. AL An 'am 19: "Say (O Muhammad, peace and blessings be upon him). What thing is the most great in witness? "Say: 'Allah (the most great!) is witness between me and you ; this Qur'an has been revealed to me that I may therewith warn you and whomsoever it may reach. Can you verily bear witness that besides Allah there are other Alihah (gods)?" Say I bear no such witness! Say but in truth he Allah is the only one Illah(God). And truly I am innocent of what you join in worship with him."

CHAPTER 16

I AM WEARING A HIJAB!

*A*fter I converted to Islam, everything felt easy in my life. I began to work again at Catholic charities but did not cover my hair for nine months. I was learning how to say my prayers but I was not visiting any mosques. I tried to find out if there were any Muslim females in my town but didn't find a single one. When you are a new Muslim, it is important to find a community in the area where you live because that is where you will need to put everything in practice. Within the community, it will be easier to learn if what you are doing is right or wrong.

My son kept sending me books about Islam to read. I prayed but I was not feeling that I was a Muslim yet because I was missing the community element. At work, people did not see much of a difference except for when we would eat out. Unlike before, I would refuse to eat pork and would make sure to cover any cleavage. I would usually wear suits and long skirts, so they did not notice anything different. I told everyone that I was a Muslim now but they did not believe me because they thought that I was just joking. As a result, it was very hard for me since I had many male friends that wanted to hug me all the time. I hated it that fact because I felt different but I didn't know that the Lord did not like that. Like many other misconceptions, I thought that was the man who made the woman submit to him and wear the hijab.

One day an Imam[9] called me and told me that several women met on post. I went to look for a mosque but I did not see anyone there so I went back home. When my son called me, I explained to him that nobody was there but in reality I was very shy to go in the mosque. One day a sister called me with good news and told me that they meet at a sister's house every other Sunday.

We met next Sunday and I was finally able to be with sisters. Alhamdulillah! It was the most beautiful day that I had experienced after a long time. I met sisters from different nationalities. We used to take classes that discuss what Islam is all about and talked about many things. It was a different kind of conversation compared to what I used to having with my friends but the atmosphere felt like family.

Every time we would meet, we would end up spending more time than planned and we would be sure to meet in a different sister's house each time. One of the sisters is my dear friend and was a retired veteran of the Army. I noticed that some of them were retired from the United States Army or married soldiers. When we took the classes of the hijab I felt something different because I noticed that the sisters were very happy even if they were wearing a hijab in the hot humid weather.

They would either go to work or stay at home and when they talk about their marriage life it was as if it is like a dream. I wanted to have a life like that and I wanted to feel those blessings. When I started to think about my blessings, I realized that Allah was preparing me to be a Muslim all my life. I wanted to give something to Allah, like a sacrifice for him or more like an appreciation of all that he gave me in my life. Therefore, I decided to wear the hijab.

[9] Imam is the person who leads prayers in a mosque and is usually in charge of the mosque

Next Sunday during Mother's day, I brought a hijab with me but I did not have a pin to attach it correctly to itself so that it could cover my head. All I had were bobby pins and when a sister saw this she took her pin and attached my hijab together. When I arrived home, I saw my son barbequing in the front yard. He asked, "Mom, what are you wearing? Do you know that my wife's aunt is coming?" I told him that I knew but I wanted them to get used to seeing me this way because from now on that would be how I would appear to the public for the rest of my life.

After nine months, I had decided to wear the hijab. Nine months due to the wrong impression that I had and the idea that I was not married to a Muslim man. I thought that wearing the hijab in Islam was a choice if you were single, since I had seen many women who didn't wear it. I did not know that Allah had ordered women in the Quran to cover their heads. After learning that the hijab was a surah sent by Allah, I decided to wear it. However that wasn't the only reason. I wanted other people to recognize me as a Muslim woman.

After I started to wear the hijab I began to receive many blessings one of which included my older son's return with the family, which I always gave thanks to Allah for. After I converted to Islam, I did not consume alcoholic beverages and made sure to avoid pork. In addition, I stopped being the center of attention because before I used to wear a lot of makeup. I changed the way I behaved in front of men and stopped reading the daily horoscopes or tarot cards. Finally I understood why that angel was beating me so hard when my heart stopped; I had to learn a lesson and be free. The day I took the classes at the sister's house was when I started to cover my hair, it was the most beautiful experience because I noticed that the men respected me more, especially in the mall they would open doors for me with respect. A co-worker that used to work with me finally understood that he needed to be far away from me and stop trying to hug me. In *Surah An- Nur ayah 31*:

"And tell the believing women to lower their gaze (from looking at forbidden things), and protect their private parts (from illegal sexual acts) and not to show off their adornment except only that which is apparent (like both eyes for necessity to see their way or outer palms of hands or one eye or dress like veil, gloves, head-cover, apron, etc.) and to draw their veils all over juyubihinna (I.e. their bodies, faces, necks and bosoms)and not to reveal their adornment except to their husbands, or their fathers, or their husband's fathers, or their sons, or their husband son's, or their brothers, or their brother's sons or their sisters son's, or their Muslim women (their sisters in Islam), or the female slaves whom their right hand possess."

I felt valued as a woman and finally understood why a Muslim man protects and is faithful to his wife. I began to see why some of the people that I knew who wear the hijab were happy and had many blessings. Then I remembered again my favorite verse:

"If my Slave comes near to me a span, I go nearer to him a cubit; and if he comes near to me a cubit; I go nearer to him the span of (two) outstretched arms; and if he comes to me walking, I go to him running"

I began to understand the benefits and received the blessings of the person who is trying to be closer to Allah.

BLESSINGS FROM MY CONVERSION TO ISLAM

I remember when my grandmother used to cover her hair before she entered the church. Eventually, people stopped using head cover, yet my grandmother, including others her age, would

keep wearing it until she died. Oh yes, how can I forget! The famous "mantilla" I remember reading in the Bible, Corinthians 11:5:

"But every woman that pray or prophesied with her head uncover dishonor her head for that is even all one as if she were shaven." I kept thinking, but what happened with the "mantilla."?

I thought, "But… if at the end of the pages in the Bible states that we should never change what is written, why did man change it? This was the great confusion of my life.

When a human being, one that can die, changes what is written in a sacred book the truth is lost. In addition, such change is an insult to the Lord and evokes a lack of love. If the Lord said not to drink alcohol, don't drink. If he said don't get tattoos, don't do it. If he said don't acquire interest, don't do it. If he said don't consult the stars (horoscopes and magicians) just show your love to him, then don't do it. Don't do it so he can bless you with prosperity, health, and love.

The first day I wore the hijab at my job it created chaos for everyone except for me. I was working with the Hispanic population in Nashville, Tennessee a place where I normally worked with nuns.

Some of the new clients didn't want to talk to me because they thought that I didn't speak Spanish and were afraid of me because of the events of September 11. I was there to help the Hispanics but they thought that I did not speak Spanish therefore they ignored me unless I asked them if they needed some help. They would look at me surprised and ask how I knew Spanish followed by whether or not I was from the Middle East. Some of my co-workers said,

"Cardona that is enough! We know that you like fashion but this time you are exaggerating! Are you going to wear that forever?"

Something positive happened. When one of our clients was married to a Muslim Arab and had decided to study Islam after she saw me. Whenever I would see them, I would greet them with "Assalamu Alaikum". Dubious, he would still reply but it seemed that he didn't believe I was a Muslim. The first day that he saw me wearing the hijab, he said: "Mashaallah!"

One day his wife called me and told me that she wanted to study books in Spanish. She wanted to become a Muslim, "My husband said that you looked beautiful even better than before. I'm thinking of wearing the hijab as well." I was embarrassed by her husband's comments but felt happy at the same time because of her decision.

My face turned red like a tomato and searched her face for any negative reaction to her husband's comments. I knew she was a wife of a Muslim and become nervous. As a person who was new in the religion, I did not know how a Muslim wife would react about her husband making a compliment about another woman. I apologized for the situation but she disregarded stating that she agreed with her husband, which motivated her to study Islam. At that moment I started to think about how my life changed. I used to think that if I was one of those Muslim women covering their head, I would die of a heat stroke. Yet look at me now, I am doing the same.

We are supposed to do the things that the Lord sent us to do as was written. This is why the Quran came with a different way of life; it has a message.

Islam is submission to Allah. Meaning that we need to act according to what Allah wants us to do and what makes him happy. Leaving only the face and hands visible is what he asked us to do in the Quran, therefore, I wanted to please him. I know perfectly well

that a person can be a mean person even if they covered. Conversely, one can be a good person without cover. In reality what matters is all that is between you and Allah. Only the Lord knows who is going to heaven in the end and I cannot judge anyone for that because Allah knows best. I only know that I am a Muslim and liked to be recognized as one because that makes me happy. It makes me happy because Allah also feels happy when I wear the hijab.

CHAPTER 17

THOUGHTS IN 2013

*W*hen I started writing this book, I had only been a Muslim for three years. Today the world is very well educated about Muslims but I know that there are still some misconceptions about Islam. I also need to study a lot and increase my knowledge about my religion. I found this book that I wrote saved in an old disk and decided that I should publish my experiences. My experience of being a soldier's wife who felt the war from a distance and the events that led to my conversion to Islam after experiencing the struggles presented by the religion that shook the world.

I know that some themes and topics mentioned might be object of controversy, however, I just want to emphasis, once again, that my sole intention is to explain the questions that I had all my life and how they were answered.

In addition, I am not using the Bible in this book as a means to teach. I am using some verses of the Bible that kept me wondering all my life if I was worshiping God the way he was supposed to be worshipped. The only book in which I believe and follow is the Quran, which is the last book sent to humanity. A book in which one can read about many miracles, even scientific miracles that at the time were mentioned in the Quran, yet scientists did not even discover. Some examples of the scientific studies were the seven layers of the poles, the shape of the female womb, the clone of the living things, amongst many others.

Perhaps what helped me in my profound study was that I have wanted to be a Muslim during those previous five years. Some

people might not believe how a person can live in ignorance for five years but believe me it happened because Allah guides whom he wants when he wants. My mind was not open to understand the depth of this religion and it was like a detox process abandoning all the misconceptions created throughout generations and western knowledge. Today it is easy to find information on how to convert because of the Internet; however, I did not have that important tool a few years ago. The Muslims that I met before never tried to convert me with information but instead showed me how Islam was with their actions.

Eleven years have passed since my reversion. Alhamdulillah! Praise be to Lord! I have had beautiful experiences in my life, one of which was surviving stage three cancer. My daughter and younger son are not Muslims but understand my religion. I am proud of their achievements. I have a grandson who I love with all my heart. I also love his mother who not only made me a grandmother but is also a great woman and lived with us for a long time.

I have had many blessings ever since my conversion. I experienced how the life in Kuwait is for a woman, how beautiful Morocco is, and felt the texture of the pyramids in Egypt. Life is easy to understand. The sovereignty of the Lord is easy to understand and can be seen with our own eyes. I still don't understand why some people do not believe in God.

Sometimes when I look at the sky I see the infinite and if I look at the sea, I can see how deep it is and how many people can eat because of the fishes there. I feel the same when I drive and look at the cows, the chickens, the horses, and camels that provide transportation to many people. I see the plants and the trees that gave us ailments and medicines. I can only think so much of how much the love from the Lord is. This is how he proves that he exists. He gave us everything by constructing a perfect world for all of us

and there is no one who can create what he did because only the Lord can do that.

I have a great life despite my ups and downs. Like any human being, we all need to go through trials in life. I can say that because it happened to me after nine years of being a Muslim. Sometimes you think everything is perfect when suddenly one of those tests comes and you do not pass. When you realized how you felt, all you can do is to ask Allah for forgiveness because he is merciful and promise never to do it again.

To end this story, I must say that my ex-husband never converted to Islam. After twenty years in the military, he finally retired. He enjoys living in a Middle East country with my elder son. Perhaps only Allah knows the purpose he has for him. He lives a very peaceful life and does not intend to leave that country unless it is the will of Allah.

When I visited my son, I fell in love with those countries, the people there, and their quality of life. I understood why when I look at the eyes of an Arab friend they look free, yet sad. Many come to this country to find the freedom that doesn't exist because the real freedom comes from your heart and from loving yourself. When you cleanse your soul you get happiness. Sometimes after running from oppression they find themselves facing another kind of oppression where it makes them a slave for the love of money and power. Once acquired, it will be difficult to run away.

They have obtained a superficial happiness and their spirits are shattered. After coming to the states, they will work day or night and sometimes even have three jobs to make ends meet. Some may be the slaves that make other people rich or some may be rich because they have a great job or business. Money is not everything. What about tea time, the time spent with the families and friends, the time spent to take a nap, time to take things easy, and the time to enjoy

life with a few cents but plenty of good times like they do in the Middle East?

Despite having their dreams to live in the United States, their dream might never come true because in the end some people decided to go back to their country. This may be after a son dies on a drug overdose or their daughters disappoint them by refusing to wear the hijab. Sometimes, perhaps their decisions come too late. I sadly look at some of the young Arabs of today. Young Arabs with many dreams of living in western countries mostly due to technology, the Internet, western television programs. Such things increase the desire to see other lands in which they are able to dress different. Perhaps the new tool for the Devil is the Internet.

I feel disappointed because some honest individuals cannot achieve their dreams of studying in a western country. The rejection coincides with the ignorant individuals who were given the opportunity to be in a free land. Such individuals who decided to generate terrorism and kill innocent people. America is free, if you don't like that and are inconsiderate about the fact that she opened the doors for you, why would you ruin the opportunity for others go to work and support their families?

What do innocent people have to do with terrorists going to heaven? I always wondered if terrorist read the Quran. America is a beautiful country, maybe not the perfect one but a country with many opportunities. Americans participate in charities for other countries and are amongst the first to go and help countries in need. It is very sad that some Muslims that are given the opportunity to immigrate to America forgot the way our prophet taught us to behave in a foreign country in which we are supposed to respect their laws. On the other hand, as stated previously, we should also recognize when its time to stop helping and leave. What happened in Iraq was too long.

I am not a politician. However, when I saw the election of the new president I thought that it was the best election. I started to see that things were changing or at least that the mentality was changing because he was different. Commercials would frequently display the beauty that exists in black women more than ever before. Mixed raced couples started appearing on TV shows.

However, despite the appearances I knew that such promised change was not going to happen overnight. Not because of the elected president, more so, because of the people who worked with him required a revision of sorts on the interaction and understanding of different cultures. I felt that the president would be perfect for the job because of his interactions with other cultures; an understanding that would lead to better diplomatic relations with other countries. Such potential could be achieved, but other minds needed to be educated to bring success. Sadly the people that worked with him did not think the same way. We as human beings also seem to fail to understand that "Rome was not built in one day."

When I went to visit some countries, I saw many things that I was not expecting. I saw religious people and non-religious people. I still believe that Islam is not a compulsion because I read it in the Quran.

We need to gather all the knowledge we learned and put it into practice. The prophet [peace be with him] perfected a religion for us. He even said in his last sermon we should follow his sunnah. The difference between Islam and other religions is more a way of life. We do have a book of instructions, something that other people don't have and we cannot change things in order to modernize it like some young people in the Middle East do. It is sad to see "The New Generation of Muslims"; they are the ones that are always on YouTube looking for Shaiks that can issue new "rules" in Islam. These are the people that obviously damage the religion. The Arabs that Prophet Muhammed mentioned are going to change the religion

until the point that only the people that faithfully follow the Quran and the Sunnah of the Prophet will recognize each other's.

Islam is a religion and does not equal terrorism. Islam teaches us to follow the right path. Sometimes when we don't follow the book, we see calamities in our lives. Sometimes wives begin to have friends that are not Muslims and begin to somehow imitate them. When things begin to go wrong, they don't even know why they get divorced or why bad things happen in their lives.

I see it many times. I will say that when something happens in your life just think about your relationship with Allah, this is the best moment to try to get closer to Allah again. Reflect on what was wrong and what made Allah send anger? Are you smoking? Are you using the Internet while your wife sleeps? What are you doing that your marriage failed or what is causing your kids to be disobedient? One will find out and it might not be late. I really believe that only peace brings peace, love brings love, and forgiveness brings more forgiveness. IS this different of what God taught in every book?

As a Muslim woman, we should not expect others to obligate us to wear the hijab. We should know why we wear it and why we need to wear it. Here in the United States, we should not wait for a scholar to issue a law exonerating us to shake hands with men only because we are not in an Islamic country. We shouldn't stop believing in the Quran as our sacred book because the Quran is forever. If you do, then don't expect the best to come in your life or at least don't complain. I learned that the hard way but now I will be fine, inshallah!

I learned that if I do things right with Allah, he would give me happiness. I learned with time that we should not feed Satan with the things that he likes. This is not an opinion, but the truth, but you are entitled not to believe. I love my religion and there are many happy

Muslims who do things right with Allah and accept his commandments.

I urge people not to look at the bad things that some Muslims did because had I done that then I probably wouldn't be a Muslim today. I follow the only person that I should make happy for the rest of my life and that is Allah. He told me to respect my prophet, believe him, and follow his sunnah. Allah is the Lord the one who created the heavens and the earth for us human beings and animals.

My son migrated for the sake of Allah where he often studied with different sheiks. He speaks Arabic very well and I am very proud of his achievements. Alhamdulillah! When I look into the eyes of my son, I feel the peace and happiness that I never saw when he lived in America. Allah is merciful and he knows what is best. In *Sura 3.Al Imran 51*:

"Truly, Allah is my Lord and your Lord, so worship him (alone). This is the Straight Path. 52. Then when Isa (Jesus) came to know of their disbelief, he said: "who will be my helpers in Allah's cause? Al Hawariyyun (The disciples) said: we are the helpers of Allah; we believe in Allah, and bear witness that we are Muslims (i.e. we submit to Allah.)"

CHAPTER 18

THE LAST SERMON

I would like to share with the reader a very interesting piece of information that helped me to make the final decision. It is the last sermon of the Prophet and the analysis of the sermon, which follows.

The Last Sermon (Khutbah) of Prophet Muhammad (Farewell Sermon)

"O People, lend me an attentive ear, for I know not whether after this year, I shall ever be amongst you again. Therefore listen to what I am saying to you very carefully and TAKE THESE WORDS TO THOSE WHO COULD NOT BE PRESENT HERE TODAY.

O People, just as you regard this month, this day, this city as Sacred, so regard the life and property of every Muslim as a sacred trust. Return the goods entrusted to you to their rightful owners. Hurt no one so that no one may hurt you. Remember that you will indeed meet your LORD, and that HE will indeed reckon your deeds. ALLAH has forbidden you to take usury (interest), therefore all interest obligation shall henceforth be waived. Your capital, however, is yours to keep. You will neither inflict nor suffer any inequity. Allah has Judged that there shall be no interest and that all the interest due to Abbas ibn 'Abd'al Muttalib (Prophet's uncle) shall henceforth be waived...

Beware of Satan, for the safety of your religion. He has lost all hope that he will ever be able to lead you astray in big things, so beware of following him in small things.

O People, it is true that you have certain rights with regard to your women, but they also have rights over you. Remember that you have taken them as your wives only under Allah's trust and with His permission. If they abide by your right then to them belongs the right to be fed and clothed in kindness. Do treat your women well and be kind to them for they are your partners and committed helpers. And it is your right that they do not make friends with any one of whom you do not approve, as well as never to be unchaste.

O People, listen to me in earnest, worship ALLAH, say your five daily prayers (Salah), fast during the month of Ramadan, and give your wealth in Zakat. Perform Hajj if you can afford to.

All mankind is from Adam and Eve, an Arab has no superiority over a non-Arab nor a non-Arab has any superiority over an Arab; also a white has no superiority over black nor a black has any superiority over white except by piety (taqwa) and good action. Learn that every Muslim is a brother to every Muslim and that the Muslims constitute one brotherhood. Nothing shall be legitimate to a Muslim which belongs to a fellow Muslim unless it was given freely and willingly. Do not, therefore, do injustice to yourselves.

Remember, one day you will appear before ALLAH and answer your deeds. So beware, do not stray from the path of righteousness after I am gone.

O People, NO PROPHET OR APOSTLE WILL COME AFTER ME AND NO NEW FAITH WILL BE BORN. Reason well, therefore, O People, and understand words which I convey to you. I leave behind me two things, the QURAN and my example, the SUNNAH and if you follow these you will never go astray.

All those who listen to me shall pass on my words to others and those to others again; and may the last ones understand my words

better than those who listen to me directly. Be my witness, O ALLAH, that I have conveyed your message to your people".

(Reference: See Al-Bukhari, Hadith 1623, 1626, 6361) Sahih of Imam Muslim also refers to this sermon in Hadith number 98. Imam al-Tirmidhi has mentioned this sermon in Hadith nos. 1628, 2046, 2085. Imam Ahmed bin Hanbal has given us the longest and perhaps the most complete version of this sermon in his Masnud, Hadith no. 19774.)

One can heed words of wisdom and guidelines from the last sermon (khutbah) of the prophet (SAWS). His sermons emphasized on the following:

1. Sacredness of a Muslim's life and property
2. The importance of propagating this message to all others (A Muslim's responsibility thus does not end by following the religion)
3. A reminder that everyone is fully accountable for their deeds and Allah (God) will take every person into account. If everyone heeded to this fact alone, the world would be a much better place today.
4. "Hurt no one so that no one may hurt you." These words of the prophet are self explanatory.
5. The prohibition of dealing with interest (Numerous accounts in Quran and Hadith prohibit taking, giving or being a part of any transaction dealing with interest).
6. "You will neither inflict nor suffer any inequity." These words of the prophet are self explanatory.
7. The awareness of satan and how satan can work to deviate us from the right path and doing evil things.
8. Rights of women over men and rights of men over women.
9. Treatment of women with kindness.
10. Modesty and chastity in women.

11. The importance of worshiping Allah (saying your five daily prayers (Salah), fasting during the month of Ramadan, giving charity (Zakat) and performing pilgrimage (Hajj).
12. Equality amongst all (blacks, white, Arabs, non-Arabs, etc.)
13. The need to establish justice.
14. Islam is the final divine religion (Last prophet and Last Book).

~There are people who look at others as if they are "oppressed", when in reality the people who are oppressed are those who have to, according to the standards of society, prove that they look "good". Such action is a result of an effort to be accepted by their peers at work, amongst friends, or even the opposite gender. Those who do not cover do not know what a great sensation it is to be loved for who you are, for what's under the clothes; the ability to love, intelligence, courage, and the essence of the heart. The genuine love and submission only to God, not the man. When beauty fads and the skin wrinkles that is when we can say that we still have love and companionship; not just a routine that we are accustomed to over the years.~

Sakinah-Alaflah Cardona

www.ingramcontent.com/pod-product-compliance
Lightning Source LLC
Chambersburg PA
CBHW060829170526
45158CB00001B/118